A Sporting Eye

Fifty Years of Irish and International Sports Photography

First published in 2005 by Liberties Press
51 Stephens Road | Inchicore | Dublin 8 | Ireland
www.libertiespress.com | info@libertiespress.com
Liberties Press is a member of Clé, the Irish Publishers' Association
Editorial: +353 (1) 402 0805 | sean@libertiespress.com
Sales and marketing: +353 (1) 453 4363 | peter@libertiespress.com

Trade enquiries to CMD Distribution
55a Spruce Avenue | Stillorgan Industrial Park | Blackrock | County Dublin
Tel: +353 (1) 294 2560
Fax: +353 (1) 294 2564

Sales representation by Compass Ireland Independent Book Sales
38 Kerdiff Avenue | Naas | County Kildare
Tel: +353 (45) 880 805
Fax: +353 (45) 880 806

ISBN 1–905483–01–5

2 4 6 8 10 9 7 5 3 1

A CIP record for this title is available from the British Library

Designed by Joanne Murphy
Compiled by Richard Callanan
Set in Myriad 10 point

Printed in Ireland by Betaprint
Unit D1A | Bluebell Industrial Estate | Dublin 12

A Sporting Eye

Fionnbar Callanan

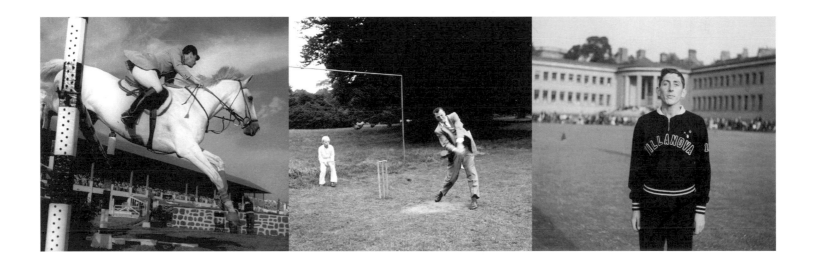

Foreword

Fionnbar Callanan has been involved in sports for as long as I can remember. I have admired his prowess in the long jump, an event in which he is still twelfth in Ireland's all-time rankings, with a jump of 7.44 metres – and that was on grass. I read his regular contributions to *World Sports*, a magazine of substance that ignited one's interest. I was aware of his status on the overseas roster of *Track & Field News,* the California-based bible of athletics. I heard his dulcets on PA systems and radio at scores of global events.

Fionnbar is responsible for a varied array of patterns, interwoven through his life, that he clearly enjoys. If the pen is mightier than the sword, then the camera is worth a Parker of pens. He has amassed sufficient photographic material to piece together a jigsaw of Irish and international sport. Famous faces and legendary names leap from these pages. Some, like himself, are jumpers; others are sprinters, throwers, race starters – presidents on a canvas that stretches across the Olympic Games, the World Championships and the European Championships in a superb 'Callanan chronology'.

Not only has he met them through his lens, many of the subjects can also be counted among his friends: stars such as Bob Mathias, who, at the age of seventeen, was Olympic decathlon gold medallist; Herb Elliott, unbeaten over both the mile and the metric mile in a stunning career; the long-jump triumvirate of Bob Beamon, Ralph Boston and Lynn Davies; Dick Fosbury, the first high jumper to 'flop' and succeed at the same time; the bubbling, unforgettable Billy Morton, a one-man Barnum and Bailey, who promoted the greatest athletics showcases.

Track and field is not the only love in Fionnbar's sports harem. He has 'a sporting eye' for Gaelic football, hurling, rugby, golf, soccer, tennis – in fact, almost every sport that you could think of. His love of his subjects is clearly evident from this book. He really should call it 'Volume I', so many are the photographs he has in stock.

Fionnbar has witnessed the evolving media coverage of sport, from the days of copytakers to the laptop – from developing and printing his own pictures to the digital wizardry of today. Systems modernise, gizmos are everywhere – everything changes, bar Callanan. He moves with the times and adapts to meet the challenge.

He retains the admirable sense of joy that should ever be the hallmark of a true sports addict. He is approaching seventy from the wrong direction; he really is only in his twenties, about to 'broad jump' into his own personal record book. His case is being heard in camera.

Jimmy Magee
November 2005

Introduction

I'm late in acting on a New Year's resolution to comply with my offspring's injunction to 'get on and do something about it' – 'it' being this collection of images from more than fifty years of sports photography. The sports came before the photography. I have pictures in my scrapbook taken as I competed 'scissors-style' in the high jump at the Synge Street CBS school sports in 1943 and 1944. I recall that I was also leading in the half-mile cycle race in 1944 until the chain came off my bike with about a hundred yards to go! I'm fairly certain that, even before then, I had played Gaelic football and hurling with under-age school teams.

In 1947, I was entered at the Leinster CBS Athletics Championships in Croke Park for the intermediate high jump, which I won with a height that was a couple of inches more than my fellow 'Synger' athlete achieved in the senior event. This led to my being doubly entered in the intermediate and senior high jump events at the Leinster Schools' Championships in Iveagh Grounds. I won both and was on my way as an athlete.

My interest had also been kindled by attending some of the big international athletics meetings which were introduced into Ireland in the post-war years by the impresario Billy Morton (pictured in College Park, in Dublin, 1969). In particular, I recall a meeting in College Park on 10 July 1946 at which Sydney Wooderson (Great Britain) ran a world-ranking two miles and later went on to win the European Championships 5000 metres in Oslo. Other big names of the time

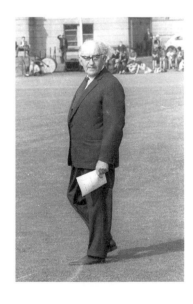

to compete in that meeting were Douglas Wilson (Great Britain), Wim Slijkhuis (Netherlands) and a Nigerian medical student who came to Dublin via Queen's University Belfast. Prince Adegboyega F. Adedoyin won Irish high jump and long jump titles and competed for Britain in the 1948 Olympics. I still have his autograph.

Of course, really big times came a couple of years later, when Billy Morton staged two massive international meetings in Lansdowne Road, one before and one after the 1948 London Olympics. The signatures of many great athletes, including Olympic gold medallists Fanny Blankers-Koen (Netherlands), Harrison Dillard (USA) and Wilbur Thompson (USA), and John Winter (Australia) also figure in my autograph book.

I think these meetings also kick-started my involvement with photography, as I borrowed my father's 'foldy-up' Kodak Brownie. Later advances could be described as fortuitous. In 1948, an uncle – 'Father Pat' – was returning to his parish in Los Angeles and left me his American-made 'Ciroflex' – a twin-lens reflex camera on the lines of the well-known Rolleiflex. This was to be my camera for more than a decade. By now, I was a solicitor's apprentice and a law student at University College Dublin and was heavily – and happily – involved in the various social and sporting activities there.

In the early fifties, I brought my Ciroflex to several sports meetings at which I was competing, until my coach, Jack Sweeney, more or less ordered me to leave the camera at home when I was taking part in an event.

Jack commanded respect: he was coach to many of the top athletes of that era, including Ronnie Delany, Brendan O'Reilly and Eamonn Kinsella. I kept my interest in photography alive, however, and was an active member of the Photographic Society of Ireland in its lofty rooms in Hume Street.

My active involvement in athletics continued, despite the frustrations of the notorious 1937 Irish athletics schism, when we ended up with two associations organising athletics in Ireland – the Amateur Athletic Union, Éire (AAUE) recognised by the International Amateur Athletic Federation (IAAF), and the the National Athletic and Cycling Association of Ireland (NACAI), which was expelled by the IAAF in 1935. During my ten years in competitive athletics, I spent five years in each association, and so qualified for a certain amount of recognition as a 'neutral' – in the quasi-political rhetoric which occasionally erupted between the two organisations! In my AAUE days, I enjoyed competing in some of the international meetings at College Park and Lansdowne Road.

In particular, I recall competing against Bob Mathias (USA), who, uniquely, won the Olympic decathlon title at the age of seventeen in London in 1948 and went on to retain that title in Helsinki in 1952; he is just thirty-two days older than me. I wrote to him after our first meeting in 1949 and, to prove a point, addressed the envelope simply: 'Bob Mathias, Athlete USA'. He got the letter. Later, in the fifties, Bob came back to Dublin on a US State Department goodwill mission and we both played in a hybrid cricket/baseball game in the US Ambassador's Residence in the Phoenix Park. I corresponded with Bob for some years and met him again at the 1960 Olympics in Rome and again, most recently, at the 2000 US Championships and Olympic Trials in Sacramento, California.

At around that time, I developed a slightly aberrant interest in international-athletics statistics; I may have been the only person in Ireland keeping track of performances outside Ireland. This interest was prompted by the book *Get to Your Marks,* by the identical twins Norris and Ross McWhirter, who later conceived and compiled *The Guinness Book of Records*. We became good friends, and they stayed in my home on their occasional Dublin visits. Through them, I became the first Irish member of the worldwide Association of Track and Field Statisticians; I am still a member. I vividly recall the awful shock and dismay I felt in 1976 when a phone call from my friend Dave Guiney informed me that Ross had been murdered by the IRA in the front garden of his home in Enfield, Middlesex. Norris died shortly before I started on this present venture, just as we approached the fiftieth anniversary of the race in which Roger Bannister broke the four-minute-mile barrier – an historic event at which Norris was the track announcer.

I kept myself up-to-date with athletics through subscriptions to various specialist athletics magazines and to the fantastic French sports daily *L'Équipe*. The Monday issue came through

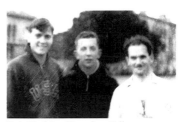

Bob Mathias, Fionnbar Callanan and Dickie O'Rafferty

my letterbox in the Tuesday-afternoon delivery. I also started a subscription to *Track & Field News*, which, fairly accurately, describes itself as 'The Bible of the Sport'. I recently sold my collection of more than fifty years of the magazine to make some space in the house!

My interest in international statistics and performances led me into a part-time career in journalism. Following the first four-minute mile by Bannister in May 1954, I was asked by Mitchel Cogley, sports editor of the *Irish Independent*, to write a preview of the impending clash at the British Empire Games in Vancouver between Bannister and the Australian John Landy, who had just broken Bannister's one-mile record. In tipping Landy to win this 'Mile of the Century', I got it wrong and was asked to write another article to 'explain myself'. This led to a request for a series of previews of the 1954 European Championships in Berne and a subsequent series of retrospective reviews.

When these were well received, I was invited by Paul McWeeney, sports editor of the *Irish Times*, to start a long-range series of previews for the 1956 Olympics in Melbourne. The title of the series was 'Around Olympic Circles'; the articles appeared on a monthly basis initially, then fortnightly, and finally weekly, with a culminating sequence of detailed summaries and, most dangerously, forecasts of the athletes who would take the first six places in each event. It took Ronnie Delany a long time to forgive me for nominating him to finish sixth in the 1,500 metres! I can't remember how I explained that in

the subsequent retrospective!

Less significantly, 1956 also marked my own last year in competitive athletics. Having ranked twelfth in the European long jump rankings for 1955 – higher than any other Irish athlete – I was listed as an Olympic prospect by the Olympic Council of Ireland, which was anxious to use me as a willing guinea pig in the political issue of Ireland's thirty-two-county Olympic status. Sadly, an injury early in 1956 contributed to an inability to match my 1955 best of 24 feet 5 inches (7.44 metres) – which, in a pipe dream, would have tied me for fourth place in Melbourne. Although that story has too many 'ifs' and 'buts', it would have been nice to have been there, instead of listening to the early-morning BBC radio commentary by Rex Alston and Harold Abrahams describing the victory of 'Delany of Éire'.

Ronnie's Olympic triumph led to an increasing interest in the worldwide scene, and it was then agreed that I would start an *Irish Times* series looking ahead to 1958, when the Empire Games were to be held in Cardiff and the European Championships in Stockholm. The series progressed until, after I had obtained my accreditation for both events, financial stringency in Westmoreland Street led to the end of my happy relationship with the *Irish Times*. Fortunately, Oliver Weldon, sports editor of the *Irish Press*, agreed to take me on board, and I covered both events for his paper and for Radio Éireann.

In 1957, still with the *Irish Times*, I had covered the one-mile race at White City, in which Britain's

Derek Ibbotson set a world record of 3 minutes 57.2 seconds, finishing ahead of Delany and the Czech Stanislav Jungwirth – who, a week earlier, had set a new world record for the 1,500 metres. This was also dubbed the 'Mile of the Century', but it was to be followed by yet another one in 1958 in Dublin. This time, I was providing statistical commentary in Radio Éireann's coverage of the race in Santry, which featured the newly crowned Empire champion, Herb Elliott, against Delany and a host of other great athletes who had featured in Cardiff. The commentator, Philip Greene, described Elliott finishing at the head of the field. I came in with 'a world record of 3 minutes 54.6 seconds and, if my timing is correct, several of the other runners have broken 4 minutes.' In fact, five runners broke the barrier, and the official new world record time was 3 minutes 54.5 seconds, with Delany finishing in third place, with a time of 3 minutes 57.5 seconds. He repeated this placing eighteen days later in the European Championships 1500 metres.

Due to my commentary and journalism work, I had little time to take photographs at the 1960 Olympics. Again, I was to cover the athletics events in Rome for the *Irish Press* and the *Evening Press*. My good friend and physician, Dr Philip Brennan, was also a keen photographer and very generously pressed me to borrow his 35mm Edixa camera, which had a 180 mm telephoto and a 50 mm macro lens. It was my first experience of working with a 35mm SLR; when not writing my twice-daily reports, I happily shot competitors such as Wilma Rudolph, Herb Elliott, Ralph Boston and Rafer Johnson on the track, and the likes of Jesse Owens and Bing Crosby in the VIP areas of the stands.

The Rome Olympics gave rise to one of my favourite sports-journalism stories. The doyen of the British sporting press at the time was Peter Wilson of the *Daily Mirror*. (Peter was the father of BBC horse-racing commentator Julian Wilson.) I had become quite friendly with Peter in the preceding years, and we met up again in the Olympic Press Centre in Rome; this was actually the well-known Catholic Retreat House, Domus Mariae, which had been converted for the Games to include a well-stocked – and well-used – bar. The telephones and telex machines were in the basement, and it was there that I met Peter, the morning after the men's 10,000 metres event.

Having run a very good six-miles race in London in mid-July, Gordon Pirie (Great Britain) was fancied by many for the 10,000 metres. In fact, Pirie finished the twenty-five laps in tenth place, more than half a lap behind the winner, Pyotr Bolotnikov (USSR). This led to much weeping and gnashing of teeth among the British press. The next morning, Peter showed me a telex message he had just received from his sports editor. It read: 'EVENING STANDARD HAS STORY – PIRIE SAYS TRACK AWFUL – GET INTERVIEW'. I laughed and asked Peter what he was going to do. He showed me his reply: 'HAVE INTERVIEWED TRACK – TRACK SAYS PIRIE AWFUL'.

By 1961, my 'day job' was as assistant solicitor

to CIÉ. I continued my athletics writing, however: the next major event was the European Championships in Belgrade in 1962 – which, again, I was covering for the *Irish Press* Group. As chance would have it, I took my old twin-lens Ciroflex on the outing and did some casual snapping away from the track. On one visit to the athletes' village, I came across world record high jumper Valeriy Brumel (USSR) playing Russian skittles with some of his teammates. This game involved the player swinging a ball on a long rope hanging from a tall curved upright and attempting to hit nine or ten skittles, much like those used in rink bowling. I took a few pictures, including one in which I moved in a little closer to Brumel.

When I got home and the film was processed, I found that I had missed the crucial point when Brumel released the ball. There he was standing on a very flat piece of timber with his hands held out in front of him at waist level – no sign of swinging ball, rope, upright or skittles! When I went into the *Irish Press* office with my next article, I brought a copy of this photograph and asked Dave Guiney, then sports editor, to guess what Brumel was doing in the picture. He got the whole sports desk involved: guesses ranged from 'conducting a choir or orchestra' to 'some form of yoga exercise'. No one got it right! Dave then decided to run the picture in the newspaper as a competition for readers; there was quite a good response. Although I can't remember if anyone got it right this time, I know that the vast majority of guesses were wide of the mark

– some *very* wide!

In all the fun of this diversion, Dave made the serious suggestion that I should bring my camera to all the events which I was attending and get some good original, exclusive pictures. I thought about this suggestion for some time. I realised that my Ciroflex was far from ideal for this type of work and, early in 1963, acquired my first 35mm SLR, a Canon with a standard 50 mm lens and a 200 mm telephoto lens. I was a loyal 'Canon man' for almost ten years, until Nikon introduced a 500 mm mirror lens in the early seventies. I then switched to Nikon and have remained loyal to that marque ever since – although, oddly enough, the 500 mm lens did not remain in favour for more than a year or two.

Those 1962 European Championships in Belgrade remain vividly in my memory for a reason only indirectly related to athletics. I was travelling overland through England, Belgium, Germany, Switzerland and Italy, and on into Yugoslavia. En route, I met up with a group of fans on a tour organised by *Athletics Weekly*, which included my good friend Maeve Kyle and her husband, Sean. Maeve was on the Irish team for the Championships. Also in the group was the leading British sports journalist Frank Taylor, who was one of the survivors of the tragic 1958 Munich air crash, in which many Manchester United players and officials had been killed. Not surprisingly, Frank was not keen on travelling by air so soon after that disaster.

Our train left Trieste at about lunchtime; we had just crossed into Yugoslavia when it came to a halt

in the middle of nowhere. After some delay, we were told that a goods train had derailed ahead of us and that there was no way through. We were told to carry our luggage and trek along the steep embankment past the derailed wagons. After a short delay, we were herded into another goods train which had come out to collect us. This train brought us a few miles into the town of Jesenice. There we learned that a passenger train was being sent out from Belgrade to collect us and so, with little alternative, we amused ourselves on the platform, tracks and sleepers of Jesenice's Central Station. We should have been in Belgrade long before the passenger train arrived to rescue us that evening.

As the journey recommenced, I was sharing a carriage with the Kyles and Frank Taylor. We were chatting and reading, not too unhappily, when there was a commotion in the passageway outside. Our reaction was 'Oh no! What now?' when the carriage door opened and someone enquired if there was a doctor among us. We said 'No' and enquired what was wrong. It was conveyed to us in a mixture of language and mime that a woman was about to have a baby down along the train. Maeve bravely undertook to go and see if she could help; she returned about half an hour later to tell us that she had just helped the woman to deliver a healthy daughter, and that mother and child were fine! The grateful parents asked Maeve her name and announced that they were naming their newly born daughter 'Maeve'. So if anyone comes across a forty-four-year-old Yugoslav-born woman

named 'Maeve something-*ovic*', that is the story of her arrival into the world!

And so, from 1963 onwards, I described myself as a 'photojournalist', since I was still writing on athletics affairs and events, while also putting many rolls of film through my cameras. My pictures were published in the Irish and British newspapers and also in specialist sports newspapers and magazines, including *L'Équipe*. Others have appeared in various athletics biographies and encyclopaedias, and I still get requests for prints. In 1976, one of my pictures of the great miler John Walker (New Zealand) appeared in the pre-Olympic issue of *Time* magazine. I cut out the inside page with my photograph and remounted and framed it with the front-page banner; such is vanity.

In 1968, there was a significant development in my photographic life. With no real prospect of getting to Mexico City for the Olympics, I took my full entitlement of annual leave in June. In July, out of the blue, I received an old-fashioned telegram from the pictures editor of the *Sunday Times* enquiring if I would cover the Olympics for that paper in mid-October. I went to my boss (in the CIÉ Legal Department) and asked about getting extra leave to go to Mexico City. I was told that this could probably be arranged, and I sent a telegram to the *Sunday Times* to confirm my availability and willingness to take on the assignment. Four days later, another telegram arrived from the *Sunday Times* cancelling the earlier offer, with apologies. Grief and puzzlement ensued!

The puzzlement was resolved a few weeks later when I met my friend the freelance photographer Ed Lacey in London. He explained that he had been retained by the *Observer* to cover the Olympics. He was subsequently asked by the *Sunday Times* to do the job, but he explained that he was already committed, and recommended me to the pictures editor. This led to the original telegram to me. At about the same time, Bryn Campbell, another well-known freelance who had a contract with the *Observer* for a certain number of days' work each year, informed the paper that he had assumed that he would be covering the Games for the *Observer* as part of his contract for the year. From there, one thing led to another; Ed was asked if he could 'get back' to the *Sunday Times*; when this proved possible, Bryn took on the *Observer* commission and Callanan settled back into a relatively quiet life.

But on the upside, Ed Lacey recommended that I should submit a portfolio of my photographs to Tom Blau, the founder and managing director of the top international agency Camera Press. Tom wrote a very laudatory and encouraging letter in reply; thus began a relationship which has continued up to the present day, under managing editor Jacqui-Ann Wald. I send Camera Press a selection of my best pictures, and they syndicate their choices around the world. I am in very good company: Camera Press also syndicates the work of such renowned photographers as Karsh of Ottawa, Norman Parkinson, Lords Snowdon and Lichfield, and many others.

My photography was not confined to athletics.

From the mid-sixties, I was covering the major events in Gaelic football and hurling at Croke Park, soccer at Dalymount Park, rugby at Lansdowne Road, showjumping at Ballsbridge, golf at Royal Dublin and Portmarnock, and tennis at Fitzwilliam (old and new). There was one year in which my photographs appeared in the official programmes of rugby internationals at Lansdowne Road, the FAI Cup Final at Dalymount Park, and the all-Ireland hurling and football finals at Croke Park.

Of course, my photographic work was nothing like as concentrated as would appear from that brief summary. My legal job entitled me to free first-class rail travel in Ireland, the UK, Europe and the USA, and I made full use of this perk in the ensuing years. I went to Munster finals in Thurles and Limerick and Connacht finals in Ballinasloe and Tuam. Overseas, I have already mentioned my trip to Belgrade; subsequent trips brought me to London, Edinburgh, Budapest, Athens, Stockholm, Helsinki, Rome and Prague, as well as the US. Rail is still my favourite mode of travel, although I gave up that perk when I returned to private legal practice in 1979. More recently, I have regained the entitlement to free travel in Ireland for a very different reason!

I should mention that, until 1986 or 1987, I worked almost exclusively in black and white, doing all my own developing and printing. At a later stage, pressure of legal work (and possibly advancing years) led me to the lazier and less time-consuming world of colour photography. I still have a great love of black-and-white

photographs, as illustrated by many of the pictures in this book.

In the early years of the new millennium, I was facing increasing ridicule from my sports-photographer friends. The reason? My adherence to old-fashioned film when many others had switched to digital photography. I think I finally surrendered to the inevitable at the 2003 World Athletics Championships in Paris. At the photographers' briefing conference on the day before the events began, about a hundred and twenty of us were asked to put our hands up if we were using film and required processing facilities. I was 50 percent of the two timid hand-raisers!

I went to the World Indoor Championships in Budapest early in 2004 with two cameras: the recently launched but 'old-fashioned' Nikon 5 film camera and the Nikon Coolpix 5700, for a 'digital trial run'. The Nikon Coolpix 5700 was not really suitable for sports photography, but the general results were sufficient to convince me to take the plunge. I have since traded in my F5 for the latest Nikon D2H digital camera – which, fortunately, uses all my old Nikon lenses. I have the added benefit – often preached to me by earlier converts – of making cash savings on film and processing, as well as time and space savings when it comes to filing and recording the results. In my 'black-and-white days' I had often come back from major events with thirty or forty rolls of thirty-six-exposure 35mm film; this added up to maybe a thousand or twelve hundred pictures to be developed, contact-printed, filed and stored. It involved seven or eights nights of drudgery in the darkroom and the same amount of time again on filing and cataloguing. Changing to colour transparencies halved the work, and I'm optimistic that the digital era will reduce it even more.

In making my selection of images for this book, I decided that the sequence should be substantially – but not rigidly – in chronological order and not grouped by subject but having some regard to visual impact as you turn the pages. I think this would be in complete accord with the personal and eclectic nature of the entire selection. I may add that, in trawling through the 'Callanan archive', I found many pictures that I had long forgotten. I hope you enjoy looking at these pictures as much as I have done in selecting them and, even more, in originally taking them in so many different places and in such different times.

Fionnbar Callanan
November 2005
www.fionnbarcallanan.com

THE FOLLOWING COUNTRY
ABBREVIATIONS HAVE BEEN USED:

AUS	Australia
ENG	England
FIN	Finland
FR	France
GB	Great Britain
IR	Republic of Ireland
NI	Northern Ireland
NZ	New Zealand
SP	Spain
USA	United States of America
WAL	Wales

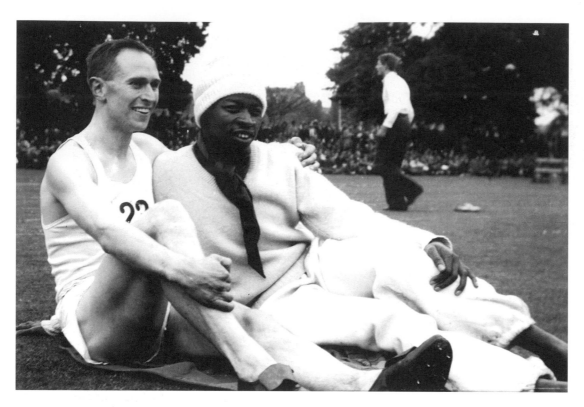

A. P. Lamont (NI) and **Prince Adegboyega Folaranmi Adedoyin** (Nigeria) relaxing in College Park during the All-Ireland Championships in 1948. Adedoyen won four titles (high jump, long jump, triple jump and 120 yard hurdles) and Lamont won the 880 yards. Adedoyin, who was studying medicine at Queen's University Belfast, represented Britain at the 1948 Olympics, coming fifth in the long jump and twelfth in the high jump.

College Park cuts up rough in 1948 before the introduction of starting blocks. **This Irish Championships (AAUE)** 100 yard final features (from left) Sean Diffley and Louis Crowe of Clonliffe Harriers and Jack Gregory, Joe Daly and Reggie Myles of Crusaders AC. The winner, Gregory, won an Olympic 4 x 100 metre relay silver medal for Great Britain in London a few weeks later.

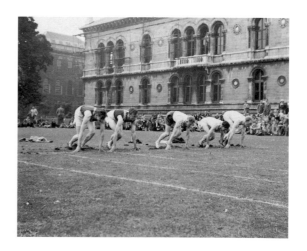

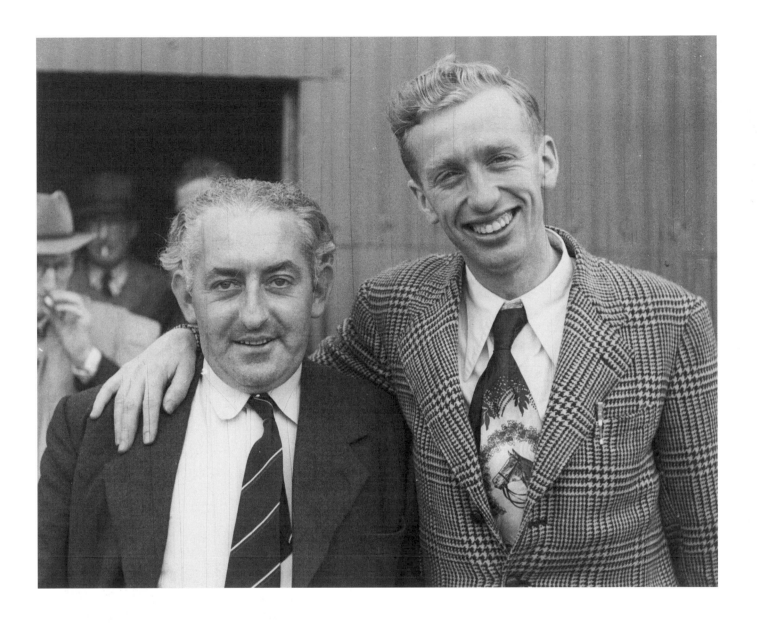

Billy Morton in 1949 with **John Joe Barry** on the day Barry returned from winning the three-mile title at the AAA Championships in London. Barry went on to an athletics scholarship in California's Villanova University. Many great Irish runners, including Jimmy Reardon, Ronnie Delany, Noel Carroll, Eamonn Coghlan, Marcus O'Sullivan and Sonia O'Sullivan, followed in his footsteps.

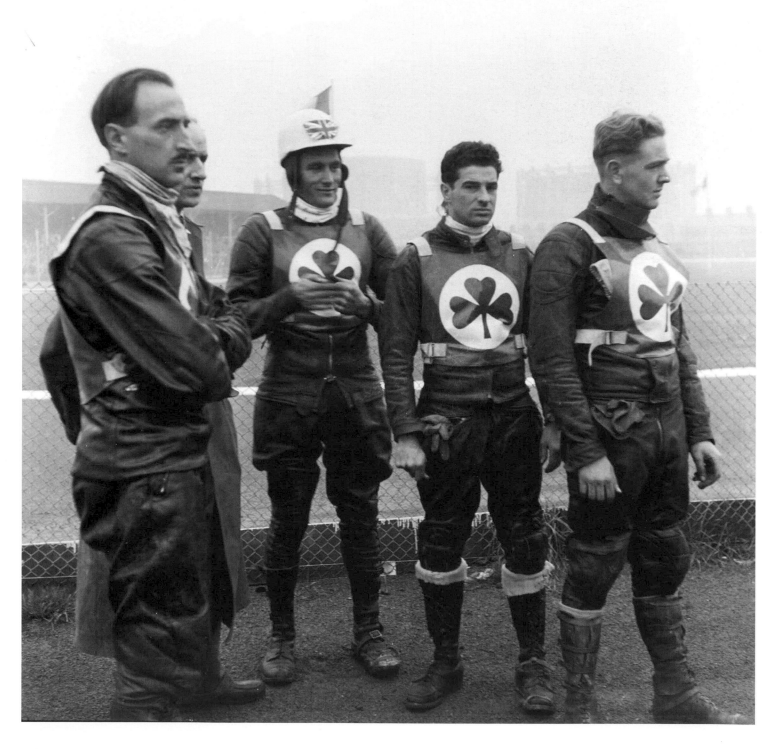

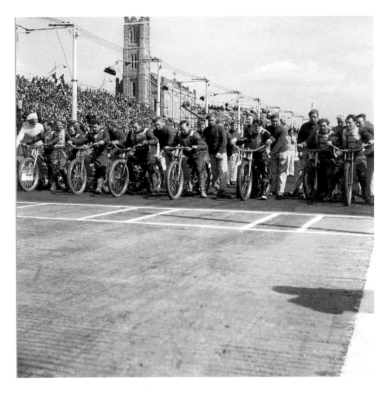
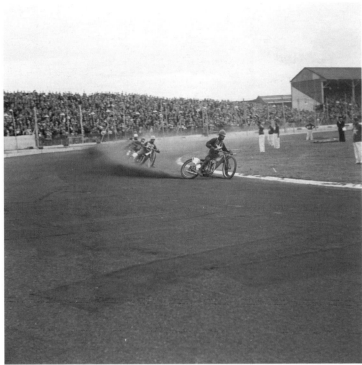

The starting line-up at Chapelizod (above left).

A full house in Shelbourne Park watches the shale fly (above right).

In the summer of 1950, speedway racing came to Dublin. The showman and promoter **Ronnie Green** brought members of his Wimbledon Dons team to Shelbourne Park each Sunday, where they raced as the Shelbourne Tigers against other English teams. Four of the Wimbledon riders in their Shelbourne Tigers vests (opposite). From left: **Mike Erskine, Cyril Brine, Ernie Roccio** and **Jim Gregory**. The American, Roccio, died from his injuries after crashing out of a race at West Ham in 1951.

In 1951, a group of the non-Wimbledon riders set up a midweek rival attraction on a new track at Chapelizod, where they raced as the Chapelizod Eagles. The popularity of the sport was short-lived, however, and speedway racing in Ireland was finished by the middle of the decade.

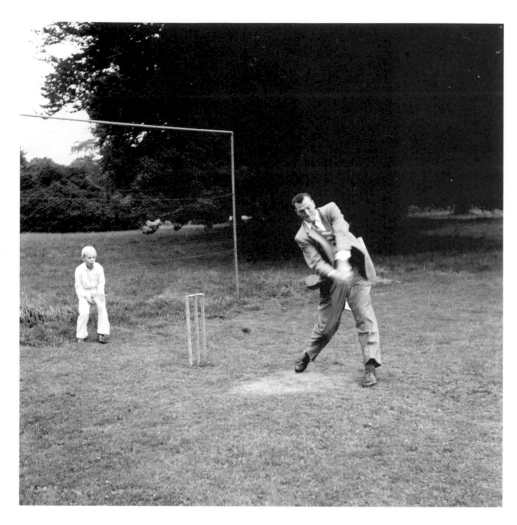

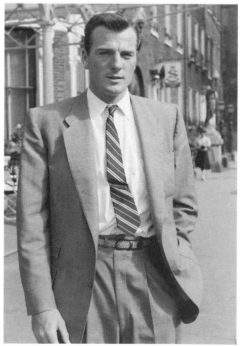

Bob Mathias (USA), 1948 and 1952 Olympic decathlon champion, poses outside the Shelbourne Hotel in 1955 (right) before trying his hand at cricket in the grounds of the US Ambassador's residence in the Phoenix Park (top).

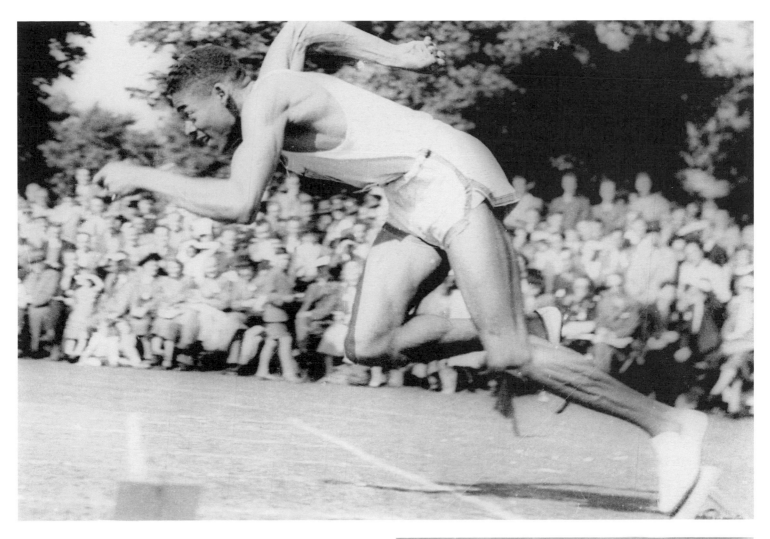

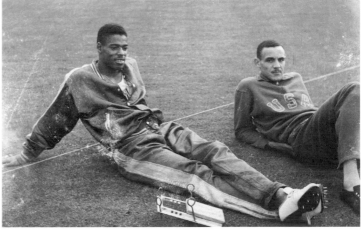

Andy Stanfield starting in the 100 yard handicap at a Clonliffe Harriers meet in Dublin's College Park in 1950. Stanfield went on to set world records at 220 yards in 1951 and 200 metres in 1952 and to win gold in the Olympic 200 metres in Helsinki in 1952.

Andy Stanfield and **Mal Whitfield** (both USA) relax during an international meeting in Dublin's College Park in August 1950. Whitfield won Olympic gold over 800 metres in 1948 and 1952. He also won gold and silver in the 4 x 400 metres relay at those Olympics and a bronze in the 400 metres in 1948.

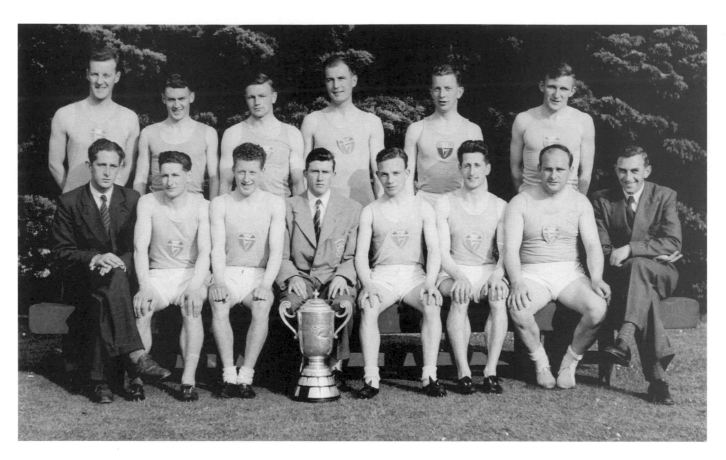

The UCD Athletic Club team in Belfield following their 1950 victory in the Irish Inter-Varsity Championships in Cork. This photographer delegated the taking of the picture so as to appear in it. The team was captained by Paddy Fitzgerald (centre front), coached by Jack Sweeney (far right, front). The captaincy later passed to Louis Crowe (third left, rear), Tom Kearney (second left, rear) and then to me (second right, rear).

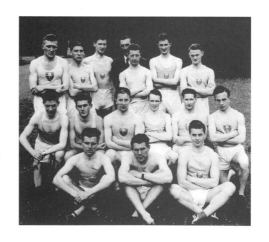

The UCDAC team which won the 1952 Inter-Varsity Championships. Back row from left: John Winters, Brian Gallagher, Jack O'Neill, Jack Sweeney (coach), Gerry Gorman, Eamon Flanagan and Brendan Bowers. Middle row: Pat Cooke, David Law, Fionnbar Callanan (captain), Diarmuid MacCarvill, Sean O'Cleirigh and Pat Quinn. Front row: Frank Cruess-Callaghan, Sean Murphy and Owen Dalton.

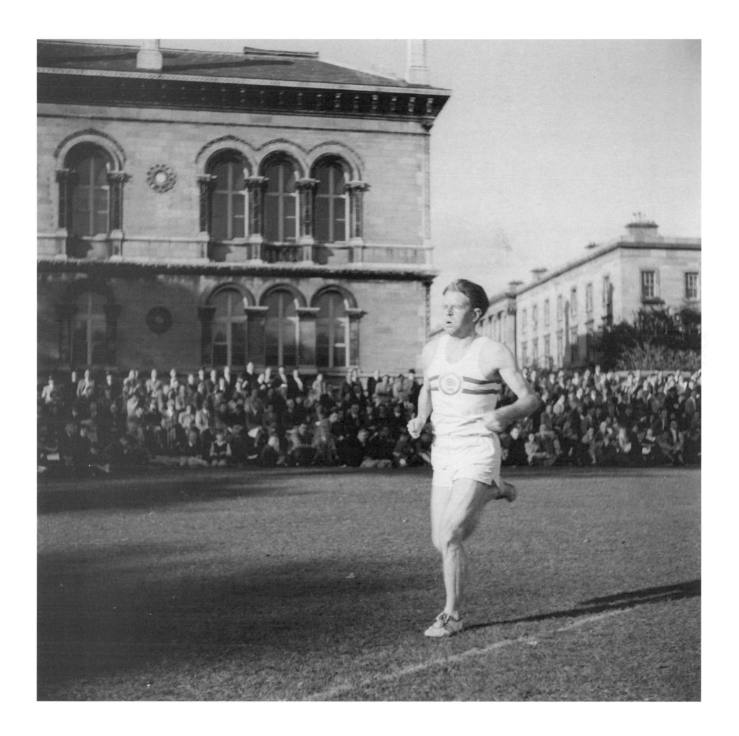

Chris Chataway (GB) during a two-mile race in College Park in 1955. Chataway, who paced Roger Bannister to the first four-minute mile in 1954, established his own niche in athletics history with victory and a world record over 5,000 metres, also in 1954.

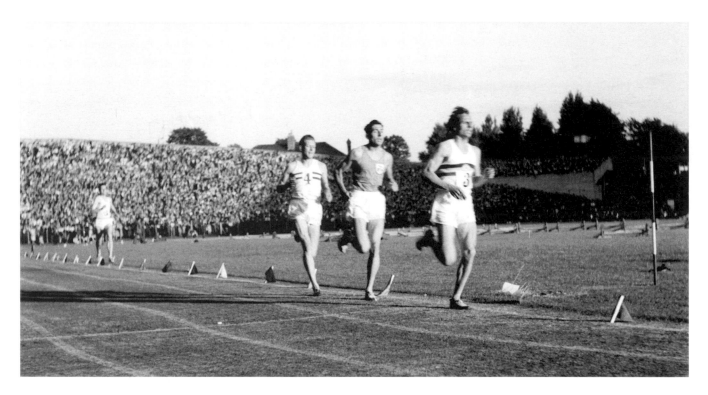

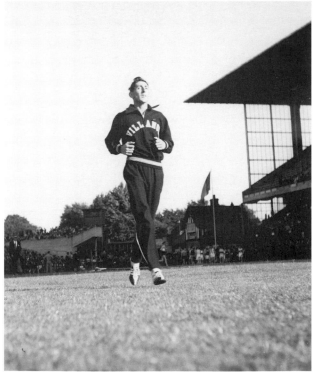

On the evening of 25 June 1956, a huge crowd in Lansdowne Road watched **Ronnie Delany** (IR) take on **Brian Hewson** (GB) over one mile – five laps of the grass track. Here, Delany (centre) and Hewson trail pacemaker **Alan Gordon** (GB) with a lap and a half to go. Although Delany and Hewson finished in the same time, the referee, interpreting the rules of the day, controversially gave Hewson the decision because Delany dived at the tape. Delany went on to win the Olympic 1500 metres in 1956, while Hewson won the European title in 1958.

Delany training at Villanova University in California.

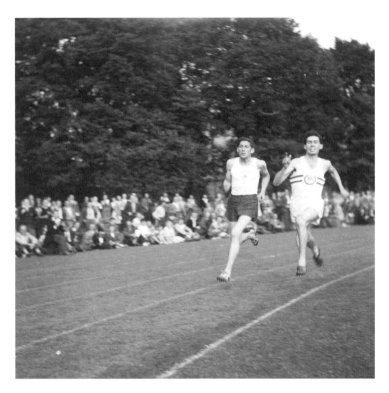

Ronnie Delany inches past Derek Johnson (GB) to set a new Irish 880 yard record in College Park in July 1955 (top left). At the 1956 Olympics, Delany took the 1,500 metres gold while Johnson took silver over 800 metres.

Ian Boyd (GB), **Derek Johnson** (GB) and **Ronnie Delany** in College Park (bottom left).

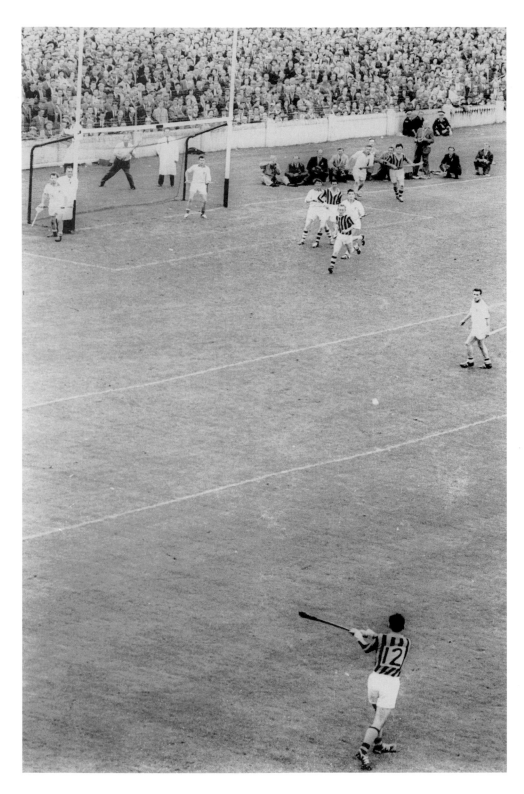

Eddie Keher strokes a free between the uprights for another Kilkenny point as they head for a 4–17 to 6–8 win over Waterford in the 1963 all-Ireland final.

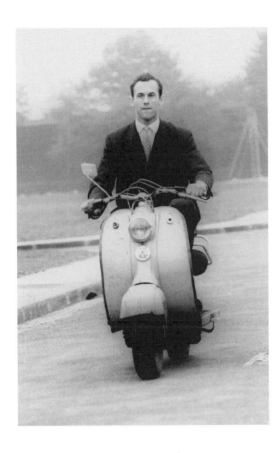

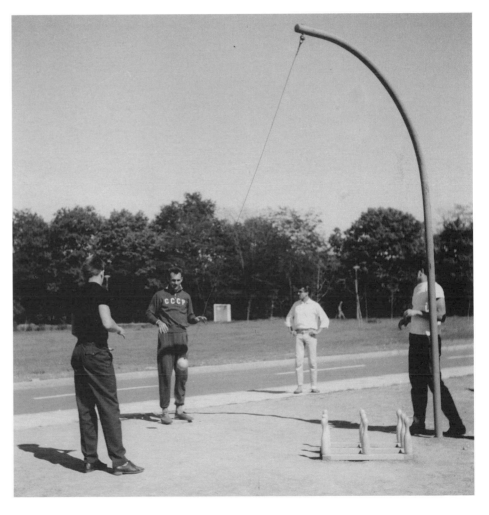

Valeriy Brumel (1942–2003) joyriding in Paris, 1962. Ironically, the five-time world-record breaker and 1964 Olympic high jump champion's career was ended by a motorcycling accident in Moscow in 1965.

Brumel playing Russian skittles with some of his teammates during the 1962 European Championships in Belgrade.

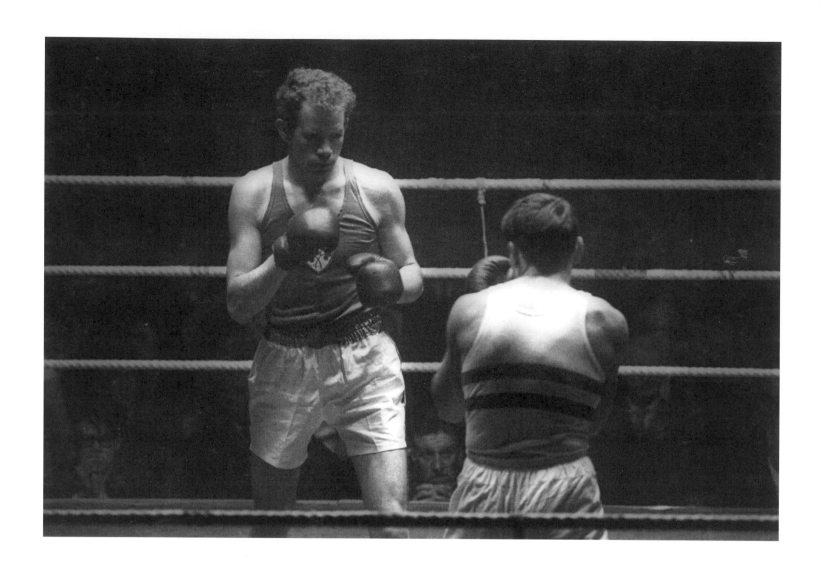

Irish junior champion **Billy Quinlan** of UCD fights the Hungarian champion **Tibor Borda** in the middleweight division of this 1963 international match in Dublin's National Stadium.

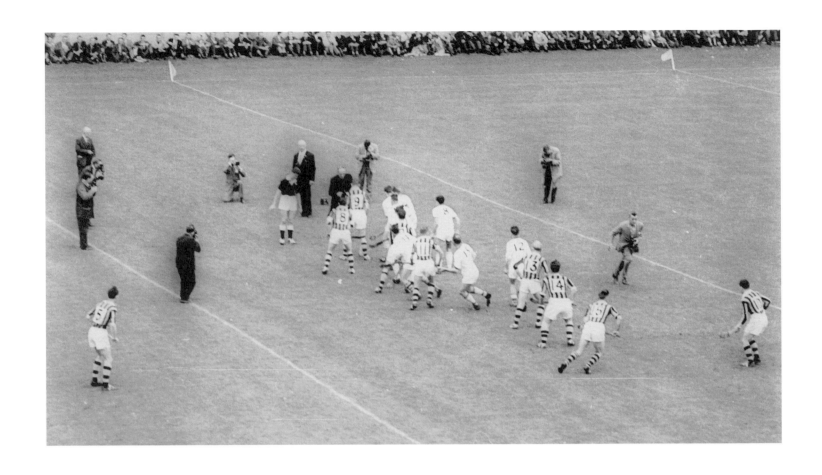

Archbishop Morris of Cashel performs the ceremonial throw-in of the sliothar for the 1963 hurling final between Kilkenny and Waterford. Kilkenny went on to win the match 4–17 to 6–8.

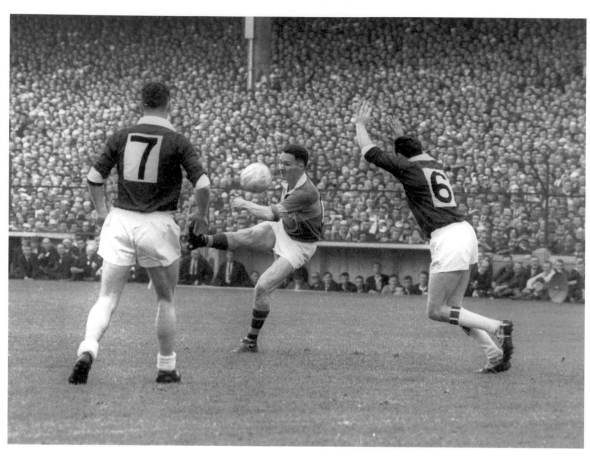

Kerry's four-time all-Ireland winner, **Mick O'Connell** (right) and (top) in action against Galway defenders Martin Newell (7) and S. Meade in the 1964 final, which Galway won by 0-15 to 0-10 .

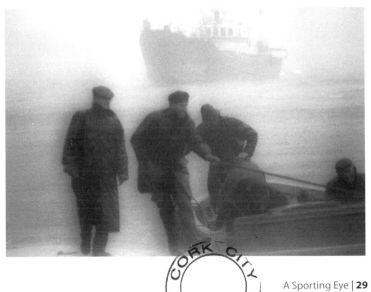

Mick O'Connell arriving from Valentia by boat for training with the Kerry team in the lead-up to the 1968 All-Ireland final.

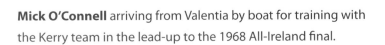

In 1964, Welsh out-half **David Watkins** makes the break that led to a Welsh try, despite the attentions of Irish players **Mike Gibson**, **Kevin Flynn**, **Jerry Walsh** and **Pat Casey** (14). The Irish pack can be seen at top left, with captain **Bill Mulcahy** on the extreme left. Wales won by three converted tries (fifteen points) to two penalty goals (six points).

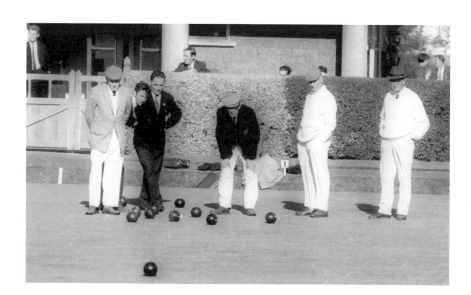

The competition was keen in the lawn bowls in **Herbert Park** in 1964.

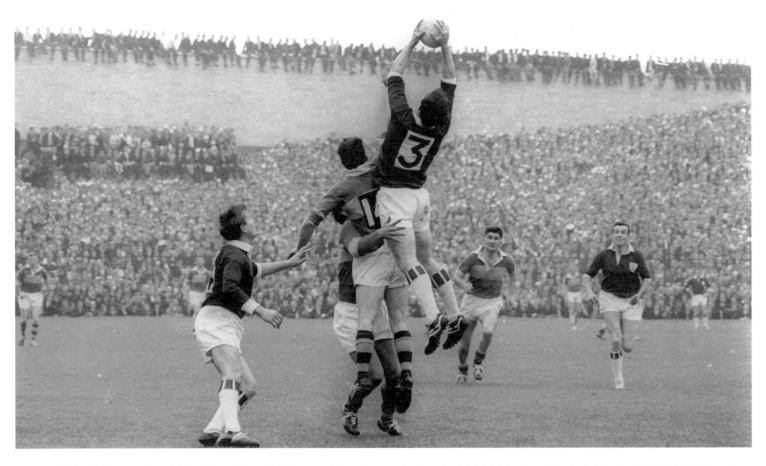

Galway's **Noel Tierney** rises high above Kerry full-forward **Tom Long** during the 1964 All-Ireland football final at Croke Park. Standing by is **John Bosco McDermott**, while in the middle distance **Mick O'Dwyer** and **Enda Colleran** await developments. Galway took the Sam Maguire that day, with a score of 0–15 to Kerry's 0–10.

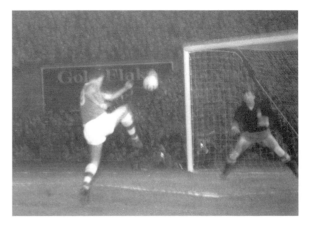

Noel Cantwell (1932–2005) – unusually, playing centre-forward – attempts to lob a shot over Spanish goalkeeper **Iribar** at Dalymount Park in 1964; Ireland lost 2–0. Later that year, for the match against England, Cantwell returned to his more usual left-back position.

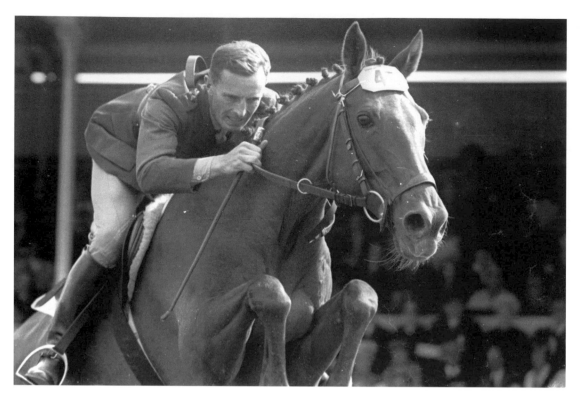

Colonel William 'Billy' Ringrose riding Loch an Easpaig at the 1965 Dublin Horse Show.

Peter Alliss, 'the voice of golf', with his caddie, waits to play during the Dunlop Masters tournament at Portmarnock in September 1965.

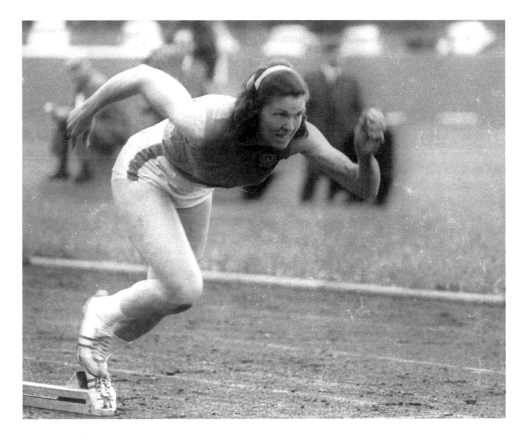

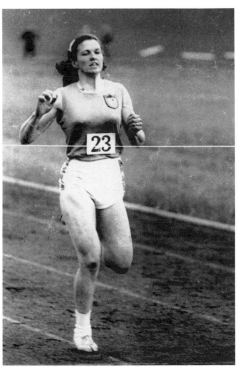

Maeve Kyle (IR) wins an international 400 metres on the original cinder track at Santry Stadium in 1965. She was the first Irishwoman to compete in the Olympic Games when she ran in the sprints at Melbourne in 1956. She competed again at the 1960 Olympics over 100 and 200 metres and was a semi-finalist over 400 and 800 metres at the 1964 Olympics. Kyle played hockey for her country between 1946 and 1970 and was part of the Triple Crown–winning team in 1950.

Maeve Kyle in 1971 (at right) with her daughter **Shauna**, who had just won an All-Ireland schools 80 metre hurdles title.

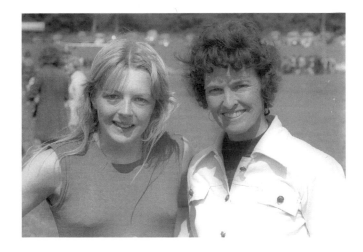

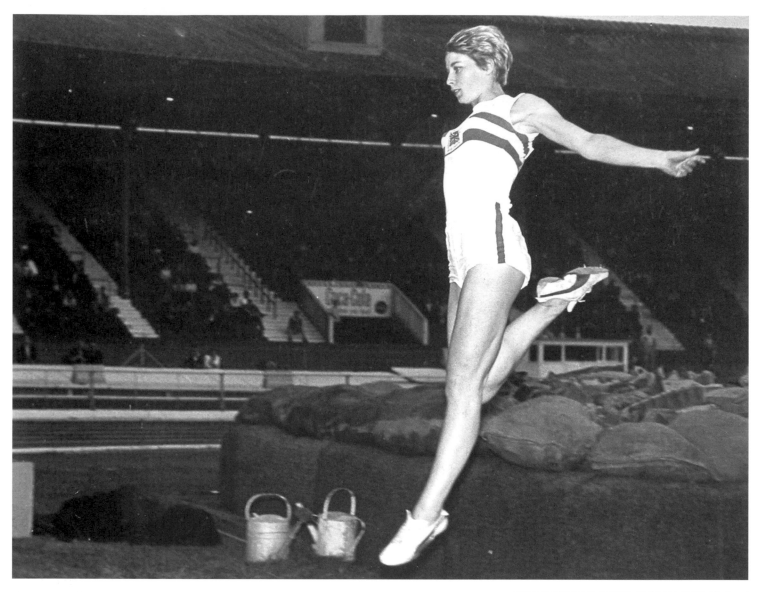

The 1964 Olympic long jump gold medalist, **Mary Rand** (GB), jumping the following year at the White City Stadium in London.

Rand later married 1968 Olympic decathlon champion **Bill Toomey** (USA), with whom she is pictured here at the 1970 Edinburgh Commonwealth Games.

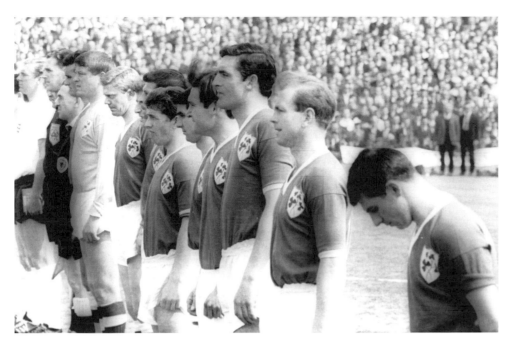

The Irish team, including **Noel Dwyer** (Swansea City), **Tony Dunne** (Manchester United), **Noel Cantwell** (Manchester United), Captain **Freddie Strahan** (Shelbourne), **Willie Browne** (Bohemians), **Mike McGrath** (Blackburn Rovers), **Johnny Giles** (Leeds United), **Andy McEvoy** (Blackburn Rovers), **Eddie Bailham** (Shamrock Rovers), **Paddy Ambrose** (Shamrock Rovers) and **Joe Haverty** (Millwall), line up for the anthems.

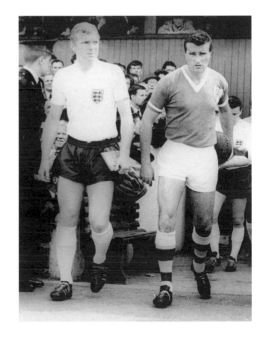

Captains **Booby Moore** (1941–93) and **Noel Cantwell** (1932–2005) lead the English and Irish teams out onto Dalymount Park in 1964 for the fifth ever match between the two teams. England won that day 3-1.

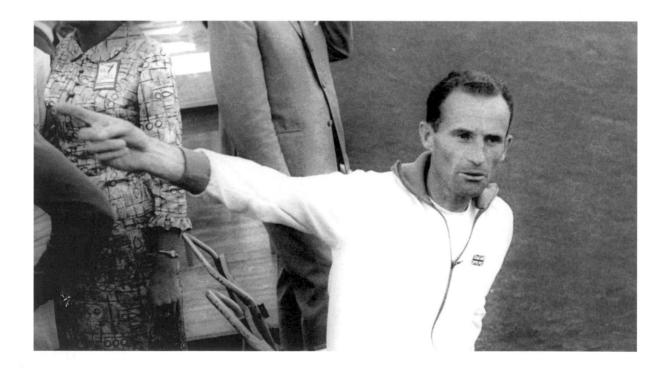

Jim Hogan, who ran for Ireland in the 1964 Olympic marathon, at the start of the 1966 European Championship marathon, which he won for Great Britain.

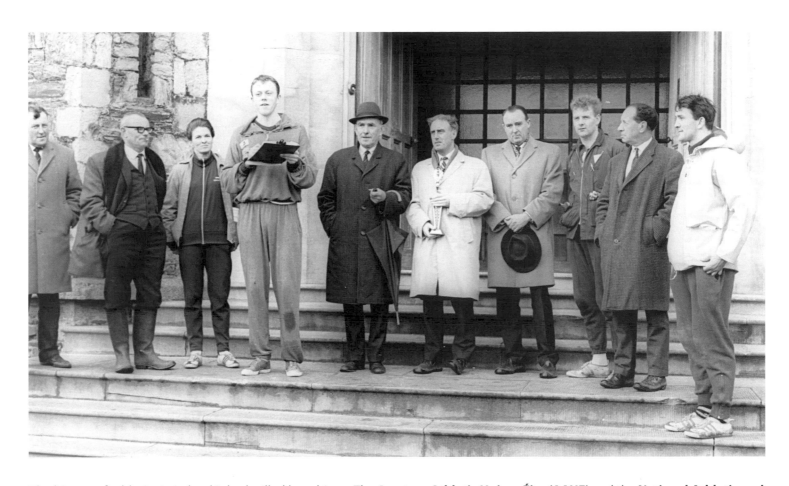

The history of athletics in Ireland is bedevilled by schisms. The **Amateur Athletic Union, Éire (AAUE)** and the **National Athletic and Cycling Association of Ireland** (NACAI) were the two principal organisations in the Republic. The NACAI had been affiliated to the International Amateur Athletic Federation (IAAF) until it was expelled in 1935 for refusing, by a single vote, to accept an IAAF ruling that it should confine its area of governance of athletics to the twenty-six counties. As a result, there were no Irish athletes at the 1936 Berlin Olympics, and Pat O'Callaghan was denied his chance of winning a third consecutive gold medal in the hammer. The AAUE was formed in 1937 to fill the void; having accepted the jurisdictional limit, it was accepted as an IAAF member. For the next three decades, various efforts were made to heal the split. The Bears Club was formed in the 1960s to foster goodwill and to provide opportunities for joint training facilities. The Bears brought off a major coup in April 1966 when they persuaded both associations to compete in a historic triangular cross-country contest – Irish Universities v. AAUE v. NACAI – at Gormanston College. A year later, while another Bears Club event was being held in Gormanston, the two associations agreed to unite and together become Bord Luthchleas na hÉireann (BLE).

This picture was taken in Gormanston following the 1966 race. UCDAC captain **Iognáid Ó Muircheartaigh**, who later became president of NUI Galway, is reading out the results. Alongside him are representatives of the two associations, the Bears Club and the Universities. From left: **Sean Fitzell** (NACAI), **Jimmy Bruce** (NACAI), **Maeve Kyle** (Bears), **Tom McDonagh** (president, NACAI), **'Gussie' Mehigan** (president, UCDAC), **Jim Moran** (president, AAUE), **Paddy Murphy** (NACAI), **Louis Vandendries** (secretary, AAUE) and **Mick Lanigan** (Bears).

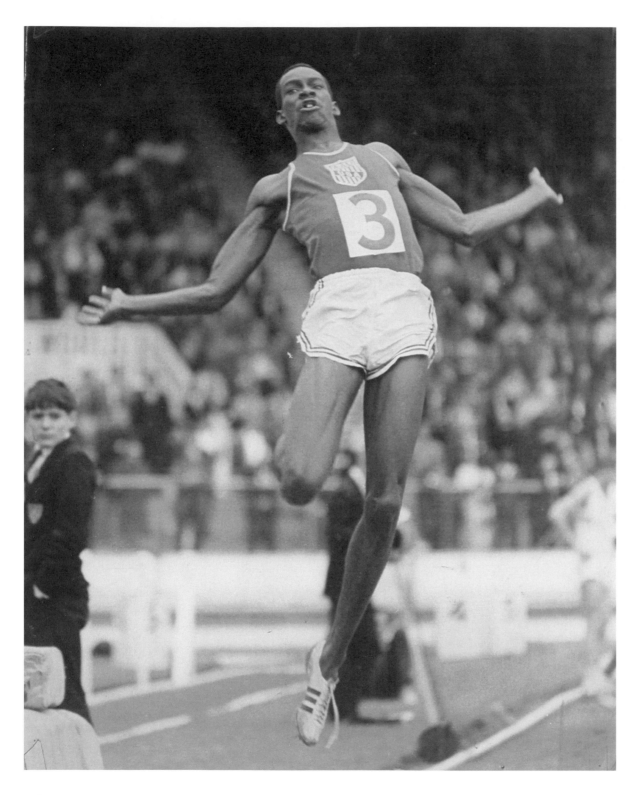

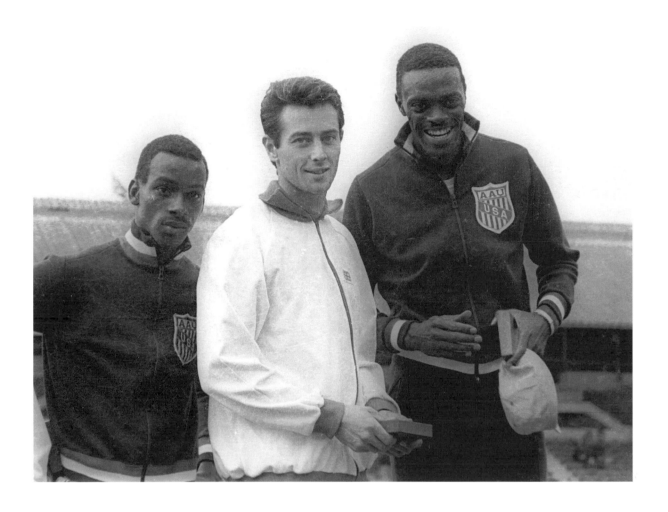

Three Olympic champions compete. At London's White City Stadium in 1967 were the reigning Olympic champion **Lynn Davies** (GB), former Olympic champion **Ralph Boston** (USA) and future Olympic champion **Bob Beamon** (USA).

Bob Beamon (opposite page) (USA) jumps into a modest third place at London's White City Stadium in August 1967, fourteen months before his Mexico City Olympic title and world record.

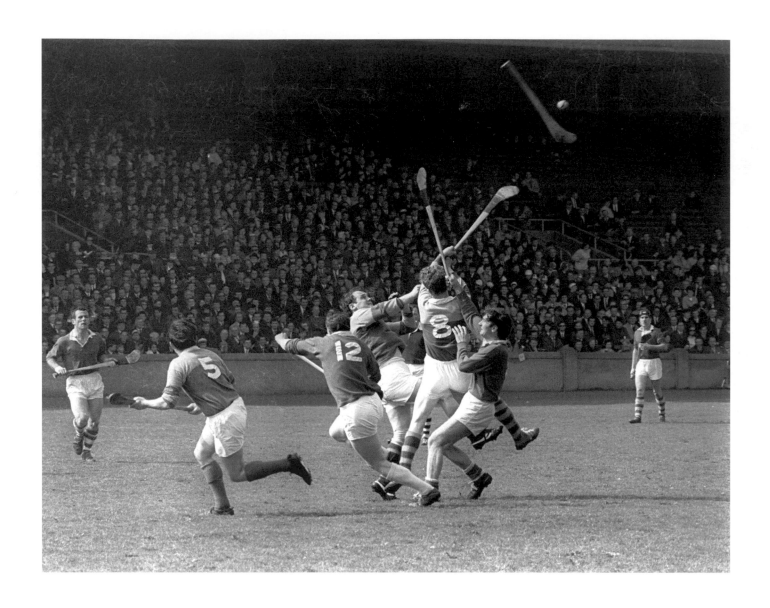

Wexford's **Paul Lynch** loses his camán during the 1969 National Hurling League final against Cork. Also in the picture are **Vinnie Staples** (Wexford, 5), **Pat Hegarty** (Cork, 12), **Michael Jacob** (Wexford, 8) and **Gerald McCarthy** (Cork).

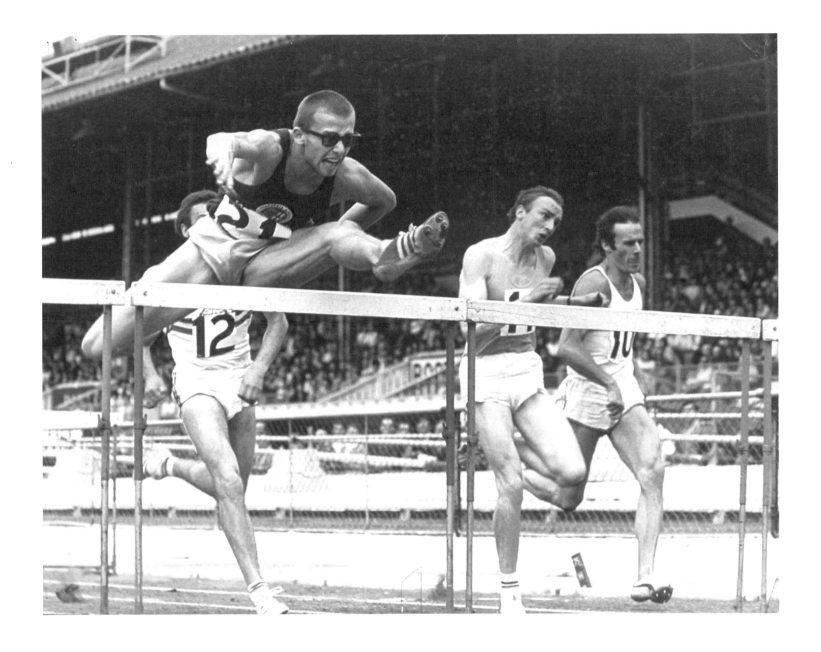

Eddy Ottoz (Italy) leads in the Final of the 120 yard hurdles at the 1967 AAA Championships in London's White City Stadium. Ottoz, a European Championships gold medalist in 1966 and 1969, missed out on an Olympic medal in Tokyo in 1964 but took bronze at the 1968 Mexico City Games. Second from right in the picture is **Alan Pascoe** (GB), who went on to win European and Commonwealth titles.

The tug-of-war (100-stone category) at the **1967 English AAA Championships** in London's White City Stadium.

President Éamon de Valera (1882–1975) takes his place in Dalymount Park for a match between Glasgow Celtic and Shamrock Rovers on 18 March 1968. The European Cup holders were held to a 2–2 draw by Rovers.

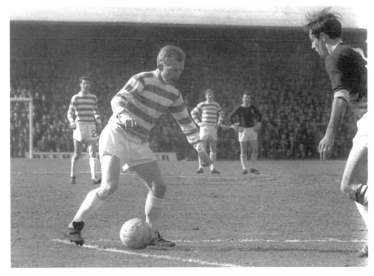

Celtic's **Jimmy Johnstone** faces Shamrock Rovers' **Pat Courtney.** Courtney played for Rovers from 1964 to 1969 and is the only person to have played on six consecutive FAI Cup–winning teams. Pat subsequently became sports editor of the Independent Newspaper Group.

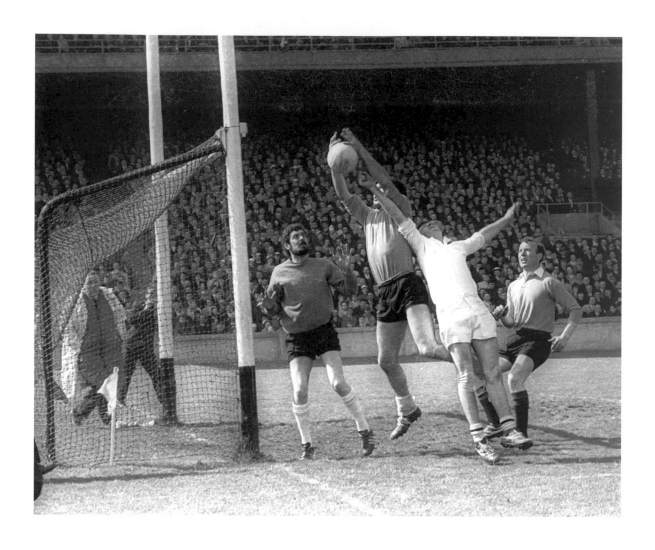

Down defenders **Danny Kelly** (keeper), **Tom O'Hare and Joe Lennon** (right) resist a Galway attack led by Liam Sammon in the 1968 National Football League semi-final. The match was eventually won by Down, who went on to win the final.

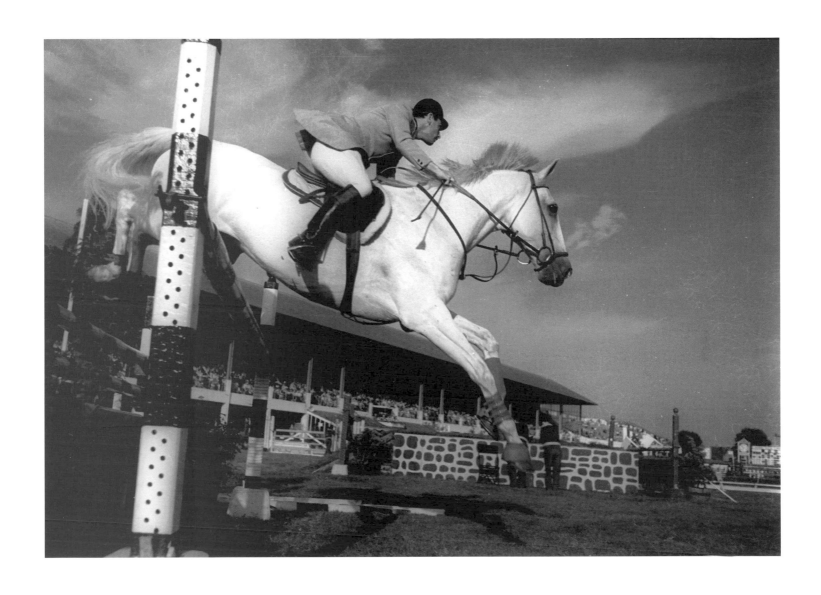

William C. Steinkraus (USA) on Snowbound competing in the International Grand Prix at the 1968 Dublin Horse Show. Second in that event, Steinkraus had the previous day captained the Aga Khan Trophy–winning USA team.

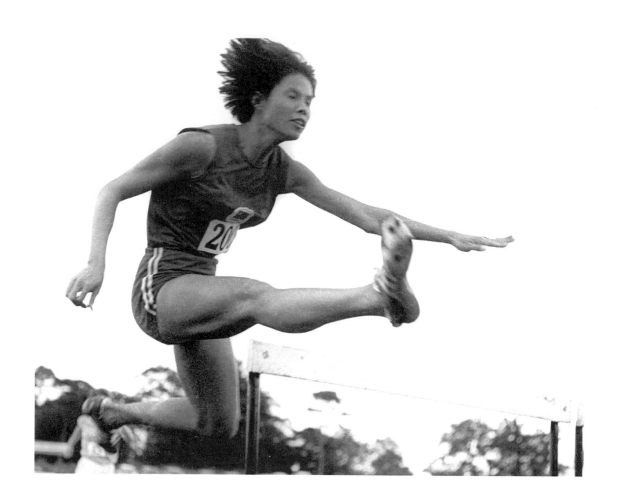

Chi Cheng of Formosa (now Taiwan) came to Santry in Dublin to compete in an international meeting in July 1969. She comfortably won all four of her events (the 100 yards, 220 yards, 100 metre hurdles and 200 metre hurdles). In the 100 yard final (pictured) she equalled the then world record of 10.3 seconds, which she subsequently broke in 1970 with a time of 10 seconds, which was never beaten. Cheng had won a bronze medal for the 80 metre hurdles at the 1968 Olympics but her real successes were to come in the following two-year period, when she won 153 out of the 154 races in which she competed. Sadly, a career-ending injury confined her role at the Munich Olympics to that of flag-bearer and Formosan team coach.

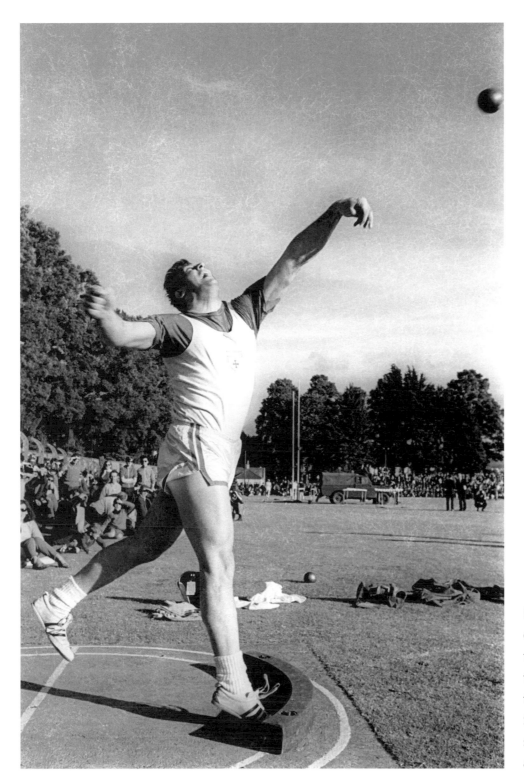

Ireland's greatest all-round weights-event athlete, **Philip Conway**, sends the shot out to a new record distance at the Cork City Sports in 1969. Phil won four Irish shot-put and five discus titles. Subsequently, he coached many of his successors to triumph in the shot, discus and hammer.

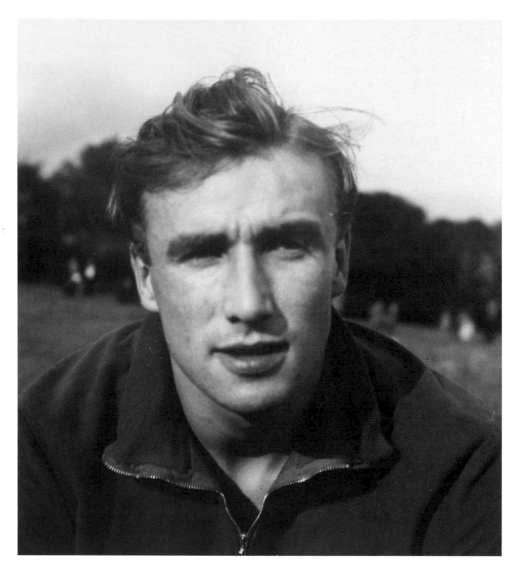

John Lawlor, whose fourth place in the 1960 hammer is the best placing at the Olympics by any Irish field-events athlete since Pat O'Callaghan's 1932 gold in the same event.

Jimmy Reardon's (above left) success as a schoolboy sprinter was eclipsed by his 1947 English AAA 400 yard title and qualification for the 1948 Olympic 400 metre semi-final. He was one of the first Irish athletes to go abroad on an athletics scholarship to Villanova University California.

Dr Kevin O'Flanagan (below), multiple Irish athletics title holder, rugby and soccer international, golfer, Bord Luthchleas na hÉireann and Olympic Council of Ireland honorary medical officer and subsequently OCI president, at an athletics meeting in Santry in 1968 prior to the Mexico City Olympics.

Kip Keino (above) in Dublin in 1966. Keino could be regarded as the first of the Kenyans who came to dominate middle- and long-distance running. He set world records over 3,000 and 5,000 metres in 1965 and won Olympic gold over 1,500 metres in 1968. In 1972, Keino won silver over 5,000 metres and gold in the 3,000 metre steeplechase in his first season in the event, at the age of thirty-two.

Bob Hayes (1942–2002) is still believed by many experts to be the fastest sprinter ever. At the 1964 Tokyo Olympics, he won the 100 metres in a world-record 10 seconds and then anchored the USA 4 x 100 metres winning team in another world-record time. After Tokyo, he switched sports to play American football for the Dallas Cowboys, and in 1972, uniquely, he won a Super Bowl ring to go with his Olympic golds. Tragically, drug and alcohol addiction and a term in jail for drug offences took their toll, and he died of liver failure aged just fifty-nine.

Bob Tisdall opening the Tailteann Games in Dublin in 1966. Tisdall unexpectedly won the 400 metre hurdles at the 1932 Olympics in Los Angeles on a great afternoon for the Irish: Pat O'Callaghan also won the hammer. Tisdall's time beat the world record but, because he knocked the last hurdle, runner-up Glenn Hardin (USA) was credited with the new record

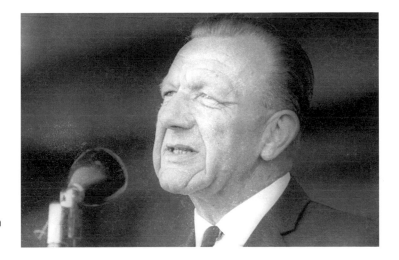

Seán Ó Siocháin, GAA general secretary from 1964 to 1979, speaks at the 1966 ceremony marking the revival of the Tailteann Games in Croke Park.

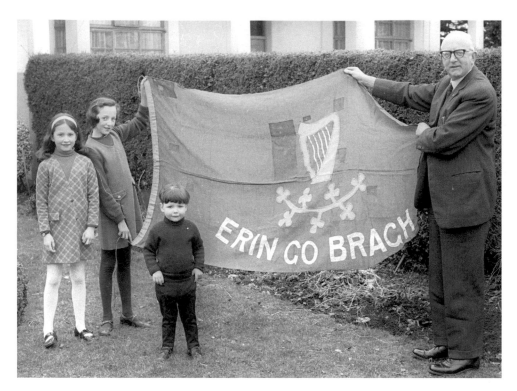

To mark the tenth anniversary of the launch of the Modern Olympic Games in Athens in 1896, the Greeks staged another Olympics in Athens in 1906. Following his victory in those 'Intercalated' Olympic Games, Irish triple jumper **Peter O'Connor** climbed the flagpole to replace the Union Jack with the flag displayed here in 1970 by Peter's son, James, and his grandchildren.

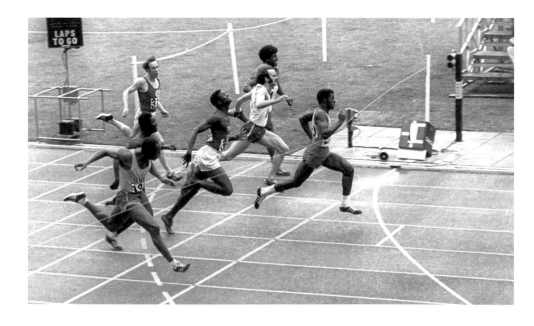

Don Quarrie (Jamaica) wins the 100 metres at the 1970 Commonwealth Games in Edinburgh from his teammate **Lennox Miller** (left) and **Hazely Crawford** (Trinidad) (centre). Quarrie completed a treble by also winning the 200 metres and the 4 x100 metres relay. A year later he repeated that treble in the Pan-American Games. In Montreal in 1976, Quarrie won Olympic gold in the 200 metres and silver in the 100 metres.

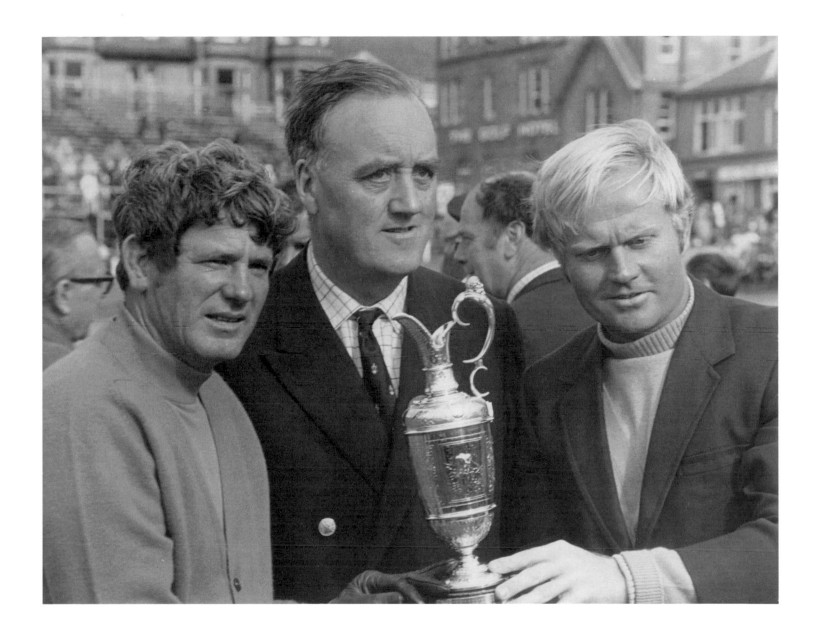

Captain of the Royal and Ancient and future Northern Ireland secretary of state **Willie Whitelaw** (1918–99) poses with **Doug Sanders** and **Jack Nicklaus** before their play-off in the 1970 British Open at St Andrews. Nicklaus went on to win the Claret Jug, which Saunders had failed to secure, missing a two-and-a-half-foot putt on the eighteenth green.

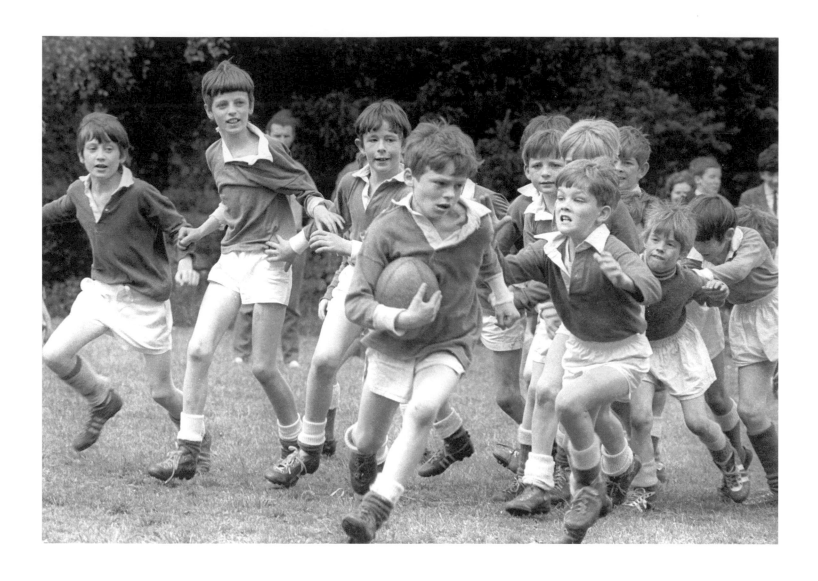

Promise may not quite be the word for what was being shown by this 1970 crop of under-elevens in Dublin's **Gonzaga College**.

Mary Peters (NI) with **Mary Rand** in 1970. Peters, who finished fourth in the 1964 pentathlon, went on to win gold in the event at the 1972 Olympics.

A pending Dáil by-election ensured a good turnout of politicians, including **Brendan Corish** and **Jack Lynch**, for the 1972 Irish Athletics Championships at Banteer in Cork.

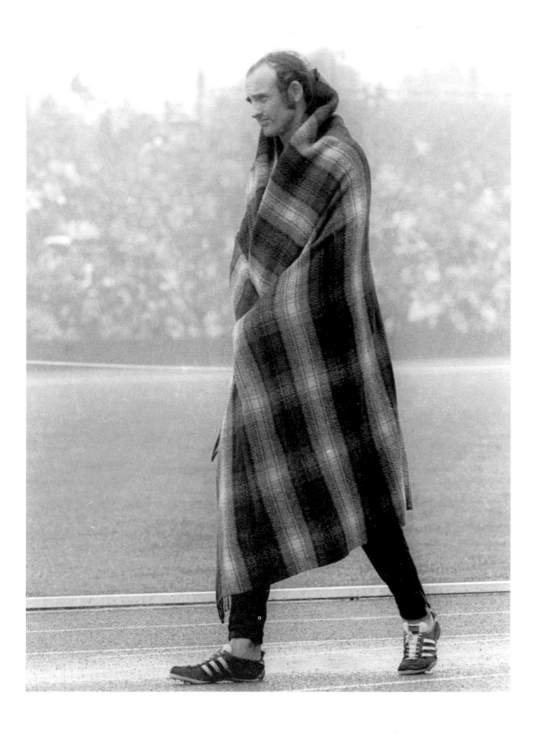

Phil May (AUS) shelters from the rain and wind during the triple jump at the 1970 Commonwealth Games in Edinburgh. He won the event and also took a silver medal in the long jump.

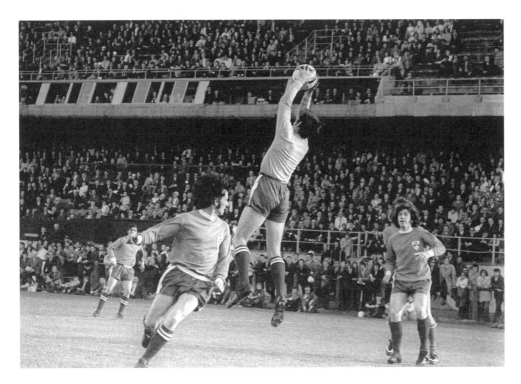

The European Nations Cup brought Italy to Lansdowne Road on 10 May 1971, the golden-jubilee year of the FAI. **Alan Kelly** (Preston North End) relieves the pressure, closely watched by **Joe Kinnear** (Tottenham Hotspur) (at right). The Italian team included such famous names as Gianni Rivera, Sandro Mazzola and goalkeeper Dino Zoff. Ireland lost 2–1.

Guy Drut (FR), the strong favourite in the 110 metres hurdles title in 1971 in Helsinki, came a cropper at an early hurdle in his heat. He went on to take silver at the 1972 Olympics, the European title in 1974 and Olympic gold in 1976. Drut subsequently became the French minister for sport and a member of the International Olympic Committee.

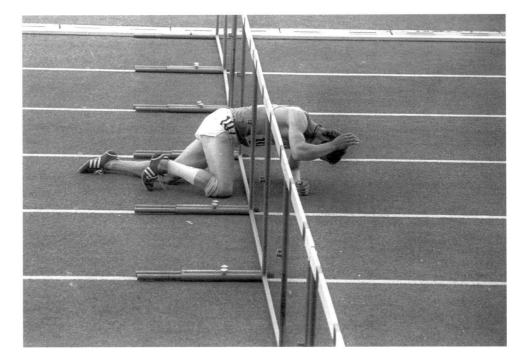

Lee Trevino (USA) playing in a semi-final match against Tony Jacklin in the 1972 Piccadilly Matchplay Championship at Wentworth. Trevino won the match but lost to Tom Weiskopf (USA) in the final.

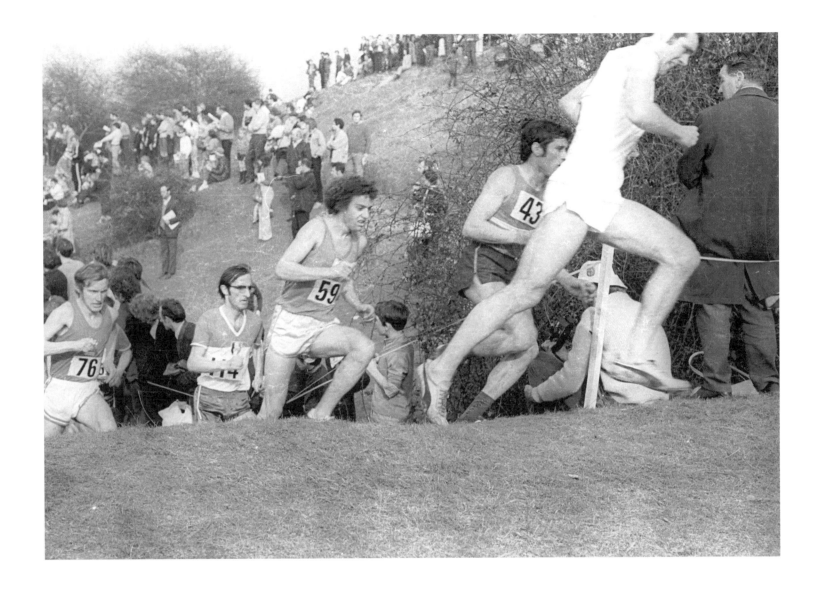

Ireland was chosen to host the World Cross-Country Championships in Limerick in 1979, when John Treacy would have the chance to defend the title he had won the previous year in Glasgow. An Post agreed to issue a commemorative stamp and chose this picture of the 1972 International Cross-Country Championships in Cambridge. The manipulated image on the stamp features, from left, **Bernie Plain** (WAL), **Jean-Yves le Flohic** (FR), **Neil Cusack** (IR), **Santiago de la Parte** (SP) and **Tony Simmons** (ENG). A postal strike postponed the issue of the stamp until after the ordinary letter rate had risen from the stamp's 8p value to 10p. As a result, the stamp became – and remains – something of a rarity.

Steve Prefontaine (1951–75) in 1972, winning the US final trials event on his home track at Oregon University. On 29 May 1975, Prefontaine crashed and died at the wheel of his convertible MG. At the time, he held every US running record from 2,000 to 10,000 metres, including the two, three and six-mile distances, and was expected to dominate over these distances at the 1976 Olympics.

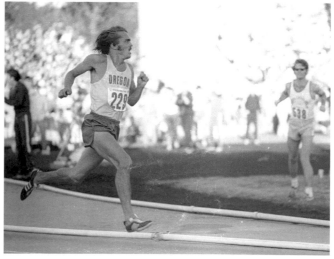

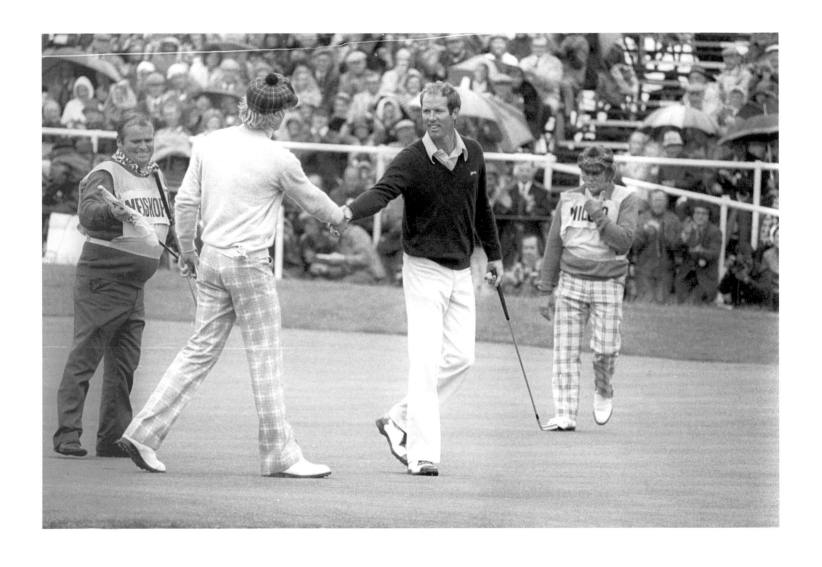

In an all-American final pairing, **Johnny Miller** (left) congratulates the new Open champion, **Tom Weiskopf,** at Troon in 1973.

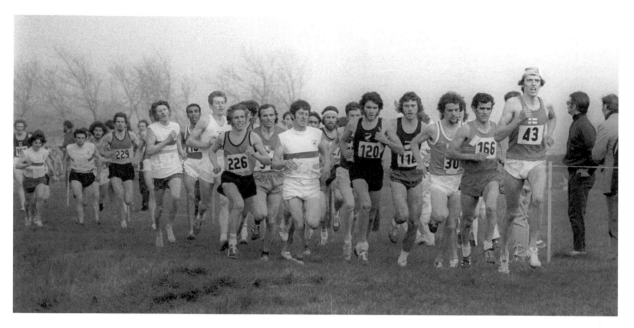

At the inaugural **World Cross-Country Championships** at Waregem in Belgium in 1973, a group of dissenting Irish runners joined the race after the first of the five laps. They represented the small breakaway NACA group which had refused to accept the 1967 settlement of the dispute between the NACAI and the AAUE, which led to the formation of BLÉ. The irregularly attired and, in some cases, bare-footed runners caused consternation among the official race entrants, including the eventual winner, Pekka Päivärinta (FIN), leading from Mariano Haro (SP), Neil Cusack (IR), Rod Dixon (NZ, 116) and Dick Tayler (NZ, 120).

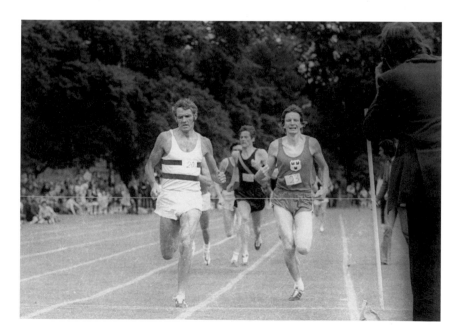

Noel Carroll wins the 800 metres from **John Dillon** and **Tom Gregan** at the 1973 Civil Service Sports in College Park. Carroll won two AAA titles (in1963 and 1966) and was also the winner at the first three successive European Indoor Games (1966–68). He competed at the Olympics in 1964 and 1968. Dillon won Irish titles over both 400 metres and 400 metres hurdles.

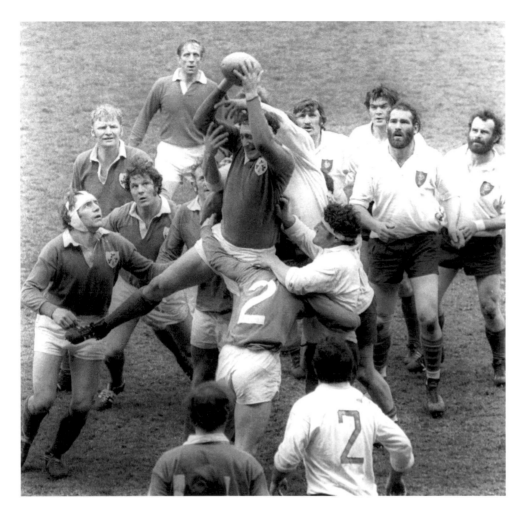

Willie John McBride wins this lineout for Ireland against France in 1973 with the support of his teammates (from top) **Pat Moore, Stewart McKinney, Ray McLoughlin** (just visible), **Mick Molloy** and **Ken Kennedy** (2).

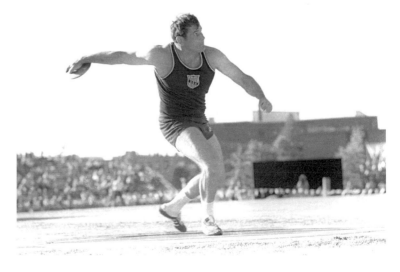

The then world record holder, **Jay Silvester**, competing in the 1972 US final Olympic trials. Silvester had an unhappy Olympic history, finishing fourth, fifth and second in, respectively, 1964, 1968 and 1972 – when he led going into the last round. In all three Games, he threw well below his form; after his third Olympic disappointment, he effectively retired from major competition.

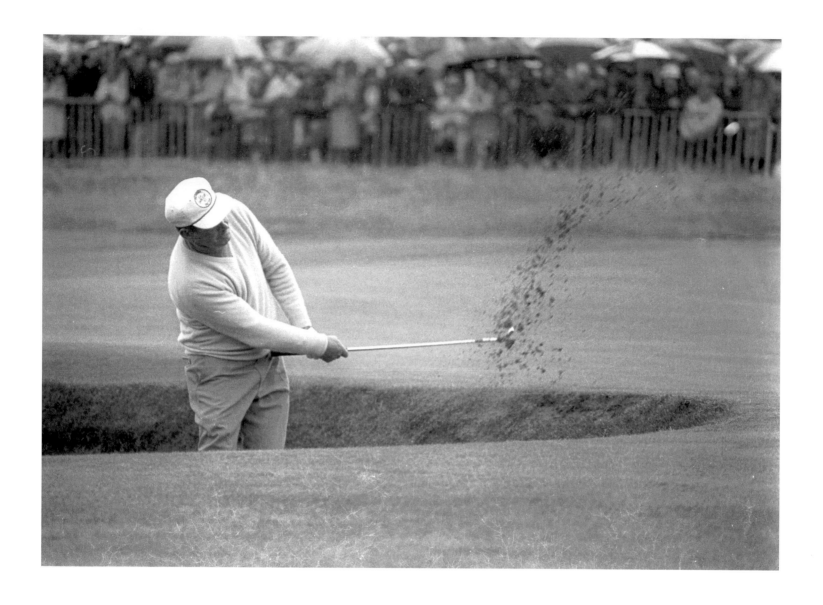

Christy O'Connor was aged forty-eight when he finished in joint seventh place in the 1973 British Open at Troon. This bunker shot to the eighteenth hole occurred during the fourth round, which O'Connor played with Jack Nicklaus, who finished in fourth place. In 1973, in partnership with Harry Bradshaw, O'Connor won the Canada Cup (now the World Cup) for Ireland. He played on ten consecutive Ryder Cup teams between 1955 and 1973.

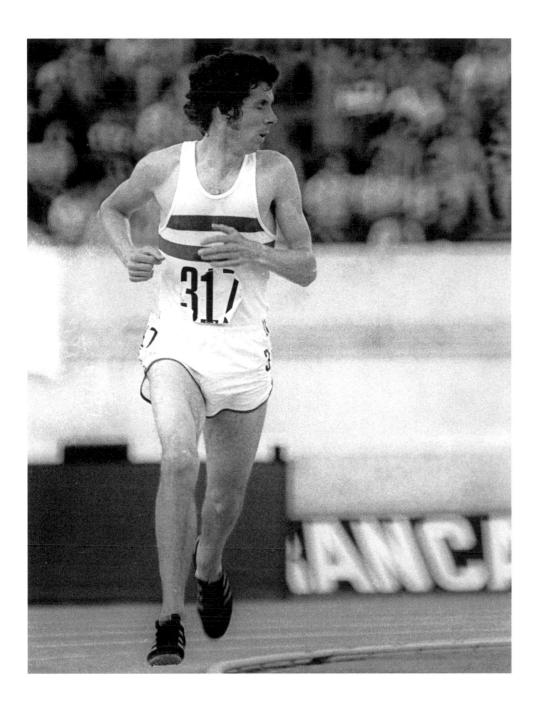

The BBC athletics commentator **Brendan Foster** (GB) ran the legs off the rest of the field to win the 5,000 metres at the 1978 European Championships in Rome by about fifty metres. At the time, Foster was also the world record holder over both 3,000 metres and two miles. In 1978, he won the Commonwealth 10,000 metres title in Edmonton.

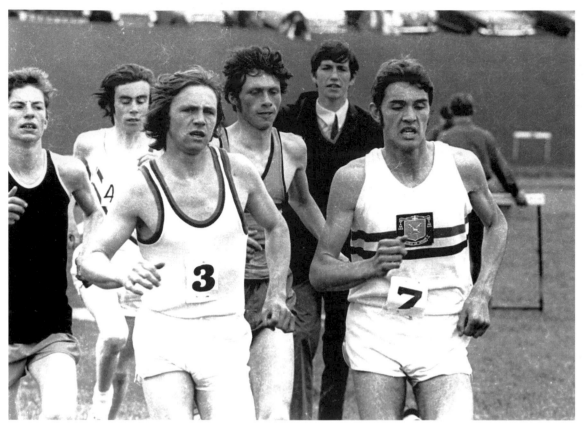

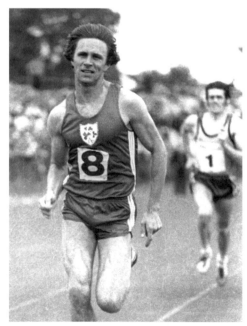

Eamonn Coghlan shares the lead in the 5,000 metres event at the 1971 All-Ireland Schools Championships in Belfield. He added this to the 1,500 metres title he had already won. Alongside him is **Greg Hannon** (7), whose subsequent performances included a fifth-placed finish in the marathon at the 1978 Commonwealth Games in Edmonton.

Coghlan returned to Belfield for many Irish championships and international events, including this one in 1979 (right).

Bridge internationals **Joe McHale** (1922–2005) (left) and **Peter Pigot** (1932–89) concentrate in Milltown Golf Club in Dublin at the Irish team trials for the 1975 World Championships.

John Walker (NZ) training at the Crystal Palace Stadium just weeks before breaking the world record for the mile in August 1975. His victory in the 1976 Olympics was followed by several hard-fought duels with Ireland's Eamonn Coghlan.

A nineteen-year-old **Sean Kelly** of the Carrick Wheelers Club on his way to winning the Irish One-Mile Championship at the 1975 Cork City Sports. Kelly went on to win twenty-two of the world's top cycling events, including seven Paris–Nice events. He also secured several stages in the Tour de France and won the Green Jersey on the 1984 Tour.

Cork's **Donie Walsh** splashes his way to victory in the 1975 Irish Senior Cross-Country Championship in Belfield.

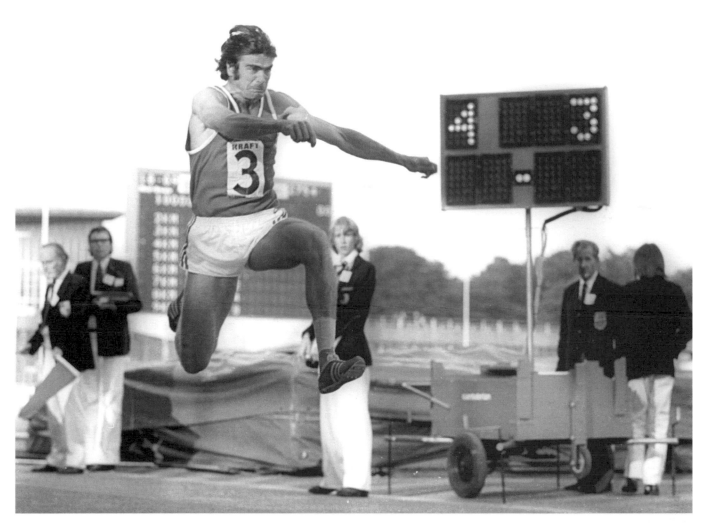

Viktor Saneyev (Georgia), jumping for the USSR in 1975 against Britain at London's Crystal Palace Stadium. The three-time Olympic triple jump champion (1968, 1972 and 1976) also won two gold and three silver European Championships medals and held three world records.

The Latvian javelin thrower **Janis Lusis** (left) with **Viktor Saneyev** in 1975. Lusis won gold, silver and bronze in the 1968, 1972 and 1976 Olympics respectively, secured four successive European titles and set two world records.

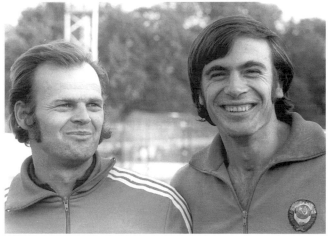

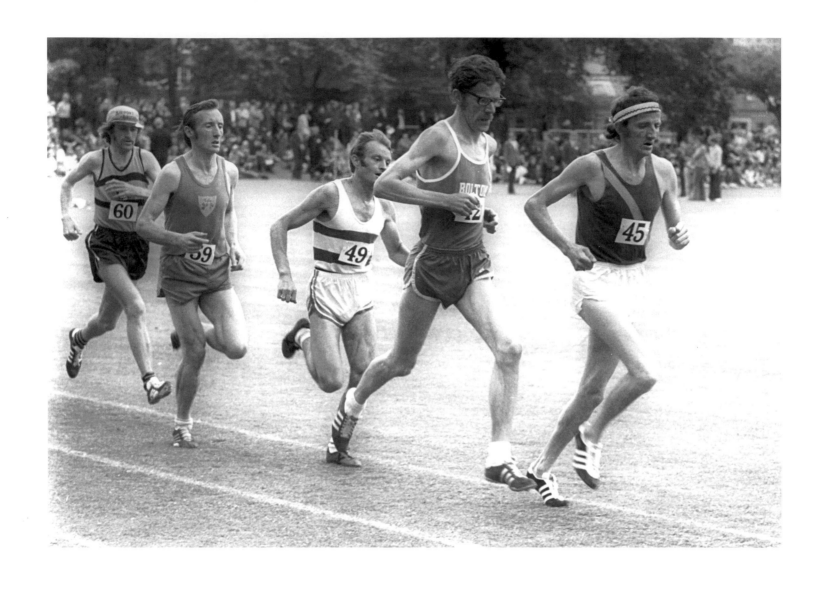

In 1973, **Danny McDaid** leads **Mike Freary** (GB), **Dessie McGann**, **Pat O'Riordan** and **Donie Walsh** in College Park.

Danny McDaid back in training – and back on the job in Letterkenny, having won the third of his four Irish national marathon titles in Limerick on Easter Sunday 1976. He ran for Ireland in nine World Cross-Country Championships, captaining the team in seven of them, most successfully in 1979 in Limerick, when John Treacy won the individual title while Danny finished eleventh, to help bring Ireland the team silver medal.

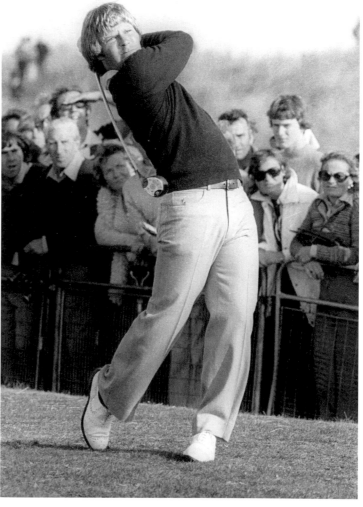

On this, his first visit to Europe, **Ben Crenshaw** (below) won the 1976 Carrolls Irish Open Championship at Portmarnock. He went on to win the US Masters tournament in 1984 and 1985.

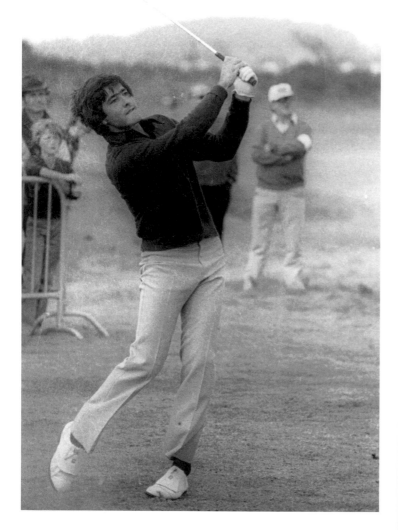

A nineteen-year-old **Seve Ballesteros** (above) at the 1976 Carrolls Irish Open Championship in Portmarnock. Ballesteros did not win that year but went on to take the title twice in later years – along with three British Open and two Masters titles.

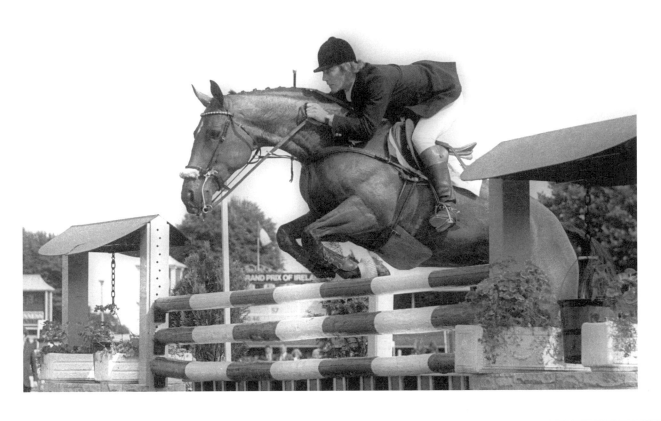

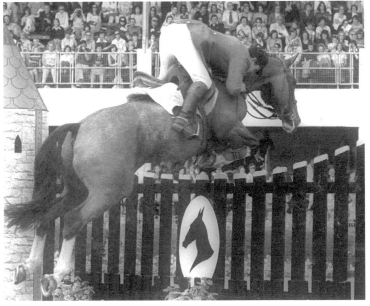

Eddie Macken on Boomerang at the 1978 Dublin Horse Show. Together, they won the Hickstead Derby in four successive years (1976–9). They were also part of the Irish team which won the Aga Khan Trophy at the Dublin Horse Show three years running (1977–9).

Harvey Smith (GB) on the Irish-bred Olympic Star winning the 1976 Dublin Horse Show International Grand Prix.

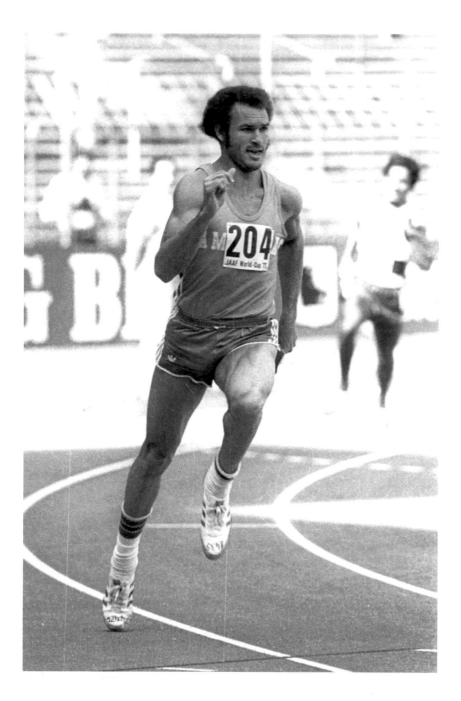

At the Inaugural World Cup in Düsseldorf in 1977, **Alberto Juantorena** (Cuba), the reigning double Olympic champion (in the 400 and 800 metres), was a strong favourite to win the 400 metres. Juantorena finished in third place but appealed that the noise from an overhead jet had caused him not to hear the gun. In the re-run of the race the following day (pictured), the Cuban won, ahead of the winner of the first race, East German Volker Beck.

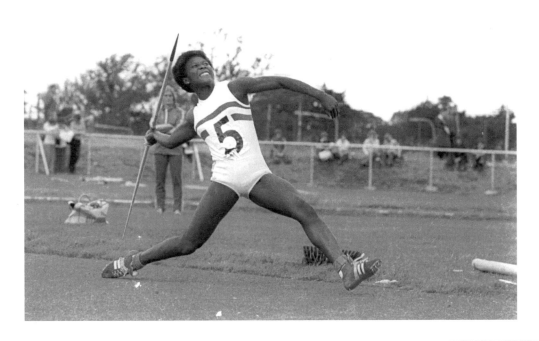

Ruth Fuchs (East Germany) (right) competing in Belfield during the European Cup semi-final in 1977. At that time, Fuchs had set four of her six world records in the event and had won Olympic titles at Munich (1972) and Montreal (1976). This day, however, she met a rare defeat, as **Tessa Sanderson** (above) bested her own UK record by a remarkable 6.96 metres. Sanderson took silver at the 1978 European Championships behind Fuchs but went on to win Olympic Gold in Los Angeles in 1984.

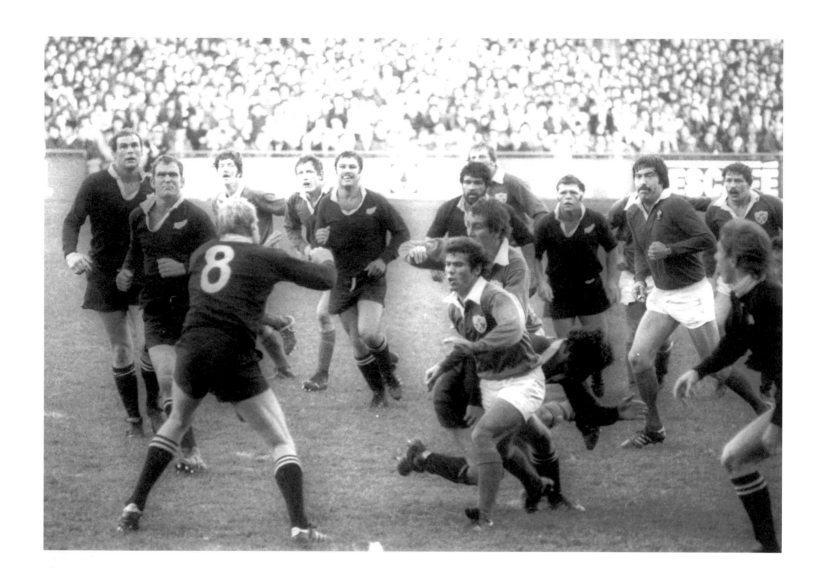

At Lansdowne Road in 1978, **Tony Ward**, with support from **Shay Deering**, is surrounded by New Zealand forwards (from left) **Andy Haden, Frank Oliver, Gary Seear** (8), Brad Johnstone, **Billy Bush** (with beard) and **Andy Dalton**. The tackler is probably Kiwi outhalf **Doug Bruce**. Other Irish players in the background are **Donal Spring, Ed Byrne, Moss Keane** and **Phil Orr** (extreme right). The referee is **Clive Norling** of Wales. New Zealand won 10–6, with all of Ireland's points being kicked by Tony Ward.

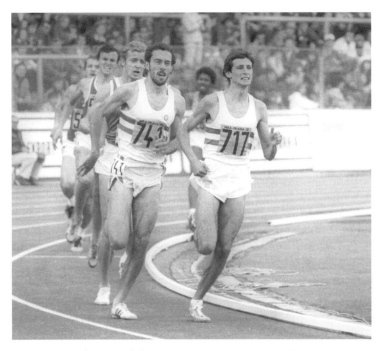

The final of the 800 metres at the 1978 European Championships in Prague, when front-running **Seb Coe** and fast-finishing **Steve Ovett** finally raced each other. The two were neck and neck here at 700 metres when the blond East German champion, **Olaf Beyer,** raced past the two Britons to win in a time two seconds faster than his previous personal best. Ovett later maintained that Beyer crossed the line and, perhaps suspiciously, continued at almost the same pace into the tunnel. Ovett and Coe next met in the 1980 Olympic finals of the 800 metres, when they finished first and second respectively, and in the 1,500 metres, when they finished third and first respectively .

Three days later, **Ovett** got a good measure of consolation by winning the 1500 metres title in a championship record, ahead of **Eamonn Coghlan** – who set an Irish record of 3 minutes 36.6 seconds, with **Dave Moorcroft** (GB) in third place.

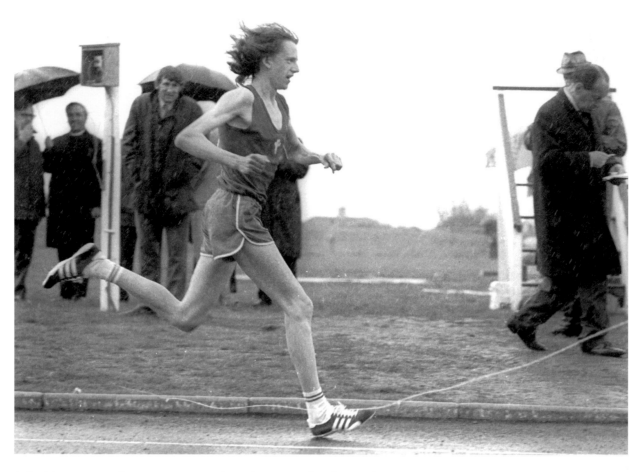

John Treacy wins the 5,000 metres title at the 1974 All-Ireland Schools Championship in Belfield.

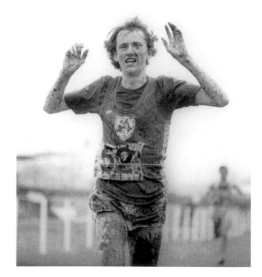

John Treacy crosses the line to win the World Cross-Country Title at Bellahouston Park, Glasgow, in 1978.

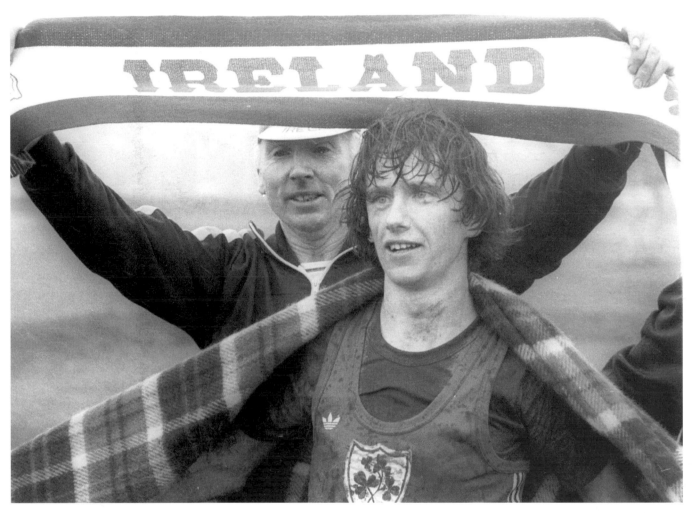

Ireland's self-proclaimed greatest sports fan, **Harry Gorman**, holds his much-travelled scarf over the victorious John Treacy.

John Treacy keeps warm while awaiting the medal ceremony. Treacy also won five Irish 5,000 metres titles but missed out on a medal at the 1978 European Championships when he was the fourth of four runners to finish within the space of three-tenths of a second. Treacy, a 10,000 metres finalist in Los Angeles, took a silver medal in the marathon at the 1984 Olympics.

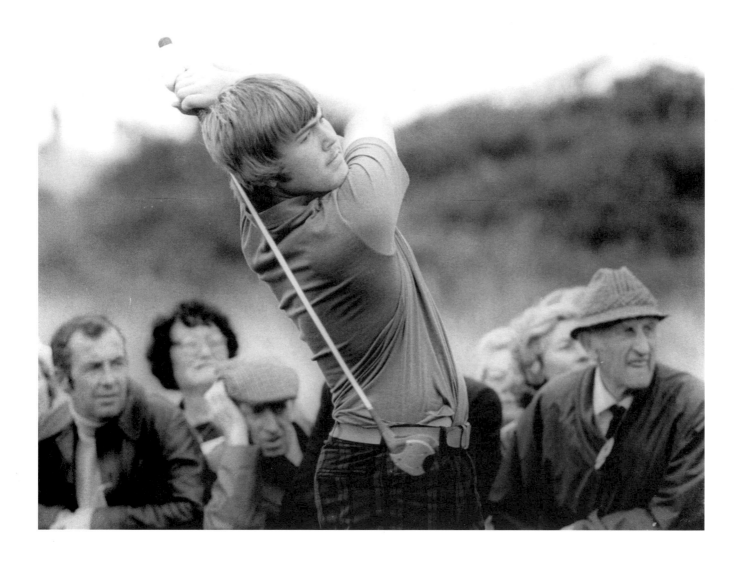

At the 1979 Carrolls Irish Open, a fifteen-year-old amateur from Warrenpoint was given a sponsor's invitation on the strength of having won the British Boys' title. **Ronan Rafferty** missed the cut but went on to play on the Walker Cup team in 1981 before turning professional. In 1990, Rafferty won the European Masters and also took New Zealand Open and Australian Matchplay titles.

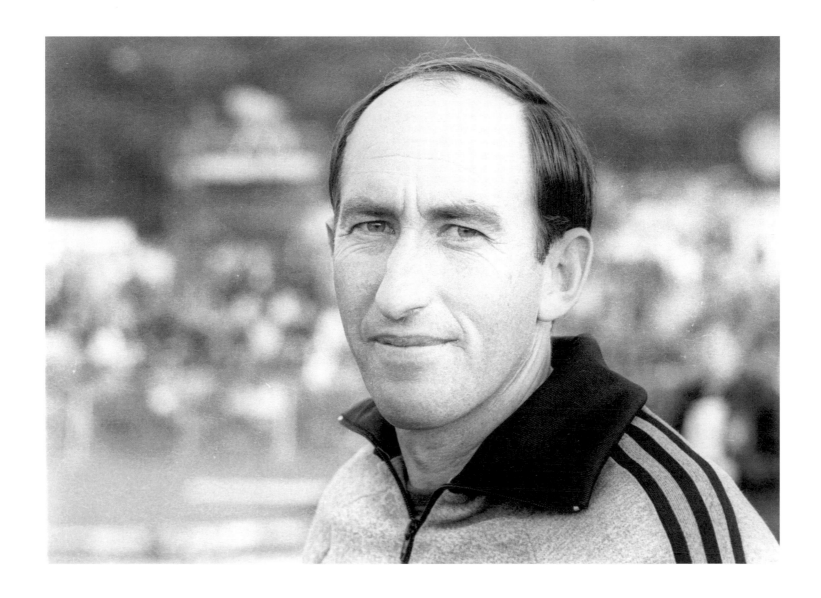

Herb Elliot (AUS) in Santry in 1978, where, twenty years earlier, he had set a world record for the mile. At the 1960 Rome Olympics, Elliot took gold over 1,500 metres and broke his own, week-old, world record. He retired in 1961 at the age of twenty-three, having lost only one race over 1,500 metres.

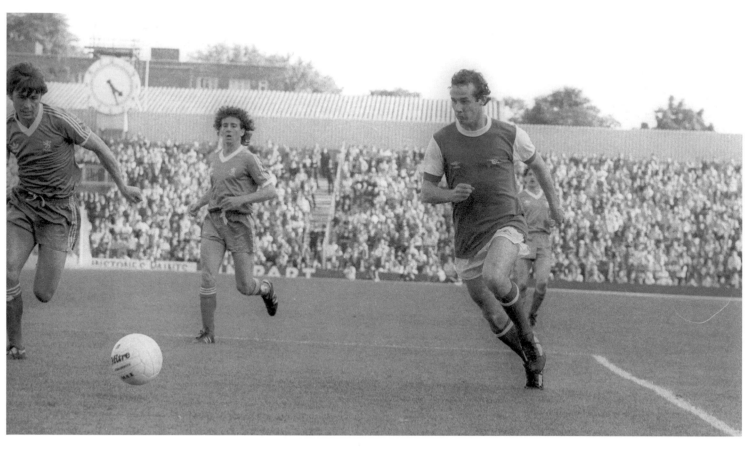

Liam Brady helps FA Cup holders Arsenal to a 2–0 win over Middlesbrough at Highbury in 1979. The team featured six Irishmen: Pat Jennings, Pat Rice, Sammy Nelson, David O'Leary, Liam Brady and Frank Stapleton, the captain.

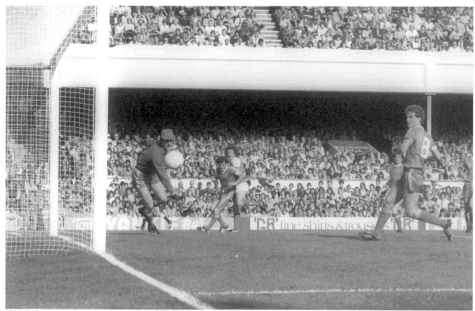

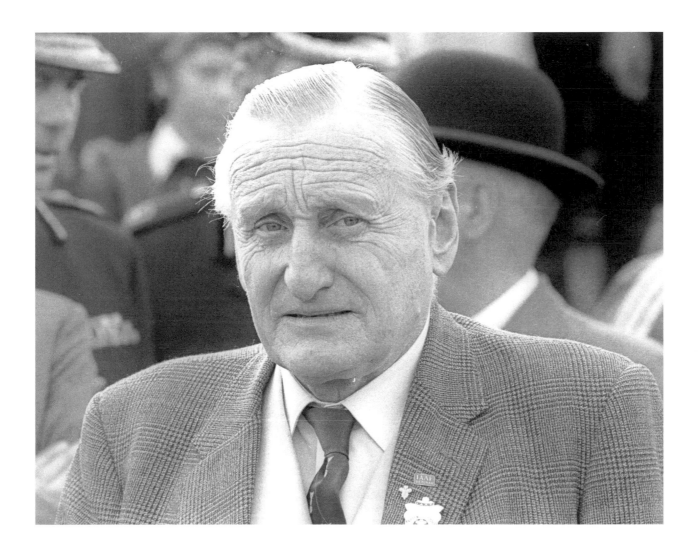

David Lord Burghley, the Sixth Marquess of Exeter, was president of the International Amateur Athletic Federation for thirty years. He is pictured here at the end of that reign, at the 1976 World Cross-Country Championships in Chepstow. As an athlete, he competed in the 110 metres hurdles at the 1924 Paris Olympics and won the 400 metres hurdles at the Amsterdam Games in 1928. In Los Angeles in 1932, he finished out of the medals as Ireland's Bob Tisdall took gold. Burghley became an MP in 1931 and was a member of the International Olympic Committee for forty-eight years.

Jim Ryun at the 1972 US Olympic Trials in Eugene, Oregon. Ryun, a world-record holder over 800 metres, 1,500 metres and the mile, was destined never to win Olympic glory. His chances were scuppered by an asthma attack at 1964's Tokyo Games, Kip Keino (Kenya) and the altitude at Mexico in 1968, and a trip at Munich in 1972.

International sports photographer **Ed Lacey** (1922–76) during a break in the 1970 British Commonwealth Games in Edinburgh. Lacey covered five Olympic Games, and his shot of Bob Beamon's 1968 Mexico City world-record jump is still published regularly.

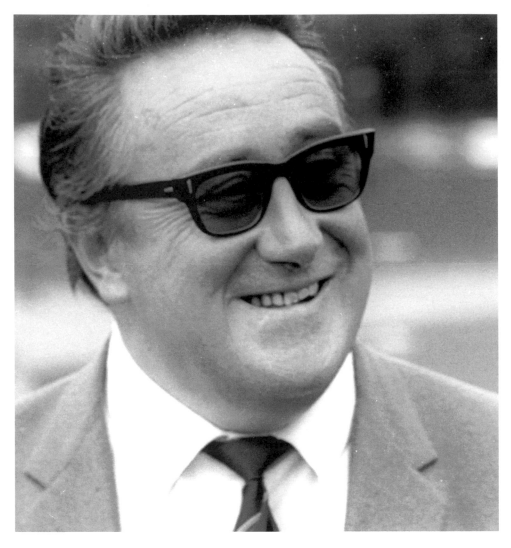

Dave Guiney (1921–2000) was a versatile athlete who competed in the shot-put for Ireland at the 1948 Olympics and won Irish titles in various events, including the long jump. This civil servant turned sports journalist became sports editor of the *Irish Press* and was a noted historian of the Olympic Games.

Brendan O'Reilly (1930–2002), former Irish and AAA high jump champion and RTÉ sports commentator, in Paris for the 1980 World Cross-Country Championships.

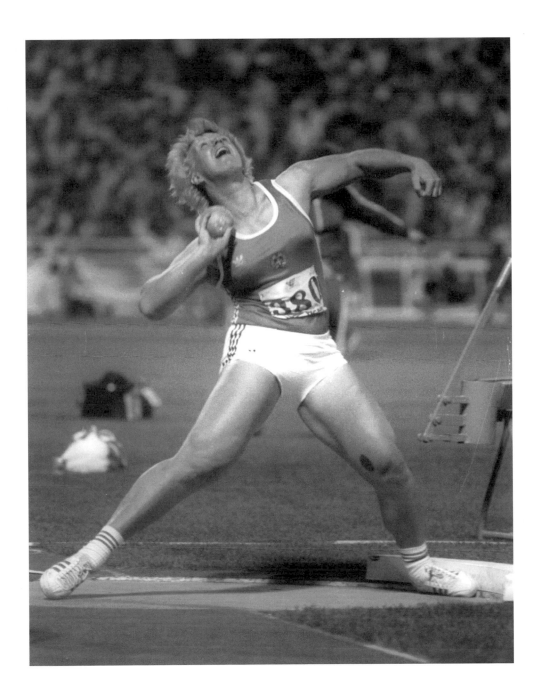

Here at the 1982 European Championships in Athens, **Ilona Slupianek** retains the 1978 title she won in Prague. This East German athlete has exactly half of the thirty best-ever performances in the women's shot-put. All thirty of those performances occurred in the 1970s and 1980s, and all but one of them were achieved by East Bloc athletes. This win for Slupianek came after a short ban following a positive drugs test in 1977. She went on to win the Olympic title in 1980 with an Olympic record which still stands.

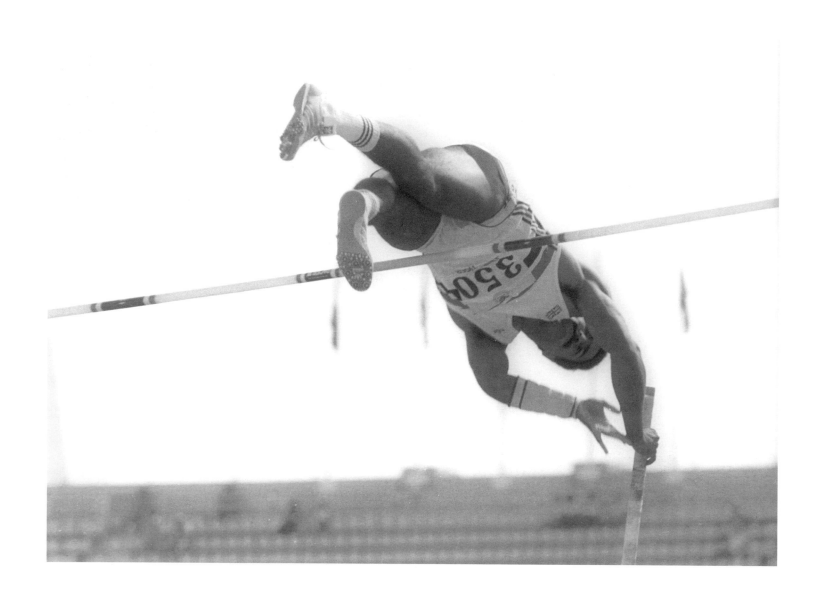

Daley Thompson in the decathlon pole vault at the 1982 European Championships in Athens. He added a gold medal at this championships to his 1980 Olympic title and successfully defended both titles in 1984 and 1986, setting four world records in the process.

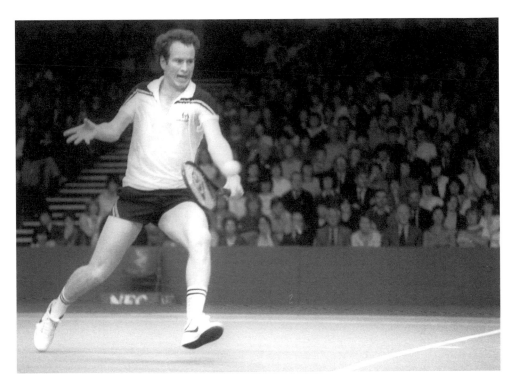

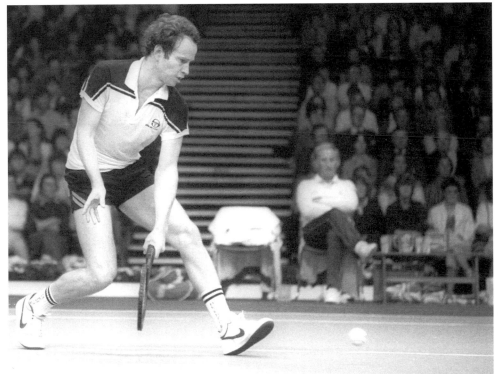

John McEnroe in Davis Cup action against Ireland in the RDS Simmonscourt Pavilion in 1983. The USA won 4–1. McEnroe won fifty-nine out of the sixty-nine Davis Cup matches he played between 1978 and 1992. He also won seven Grand Slam singles titles.

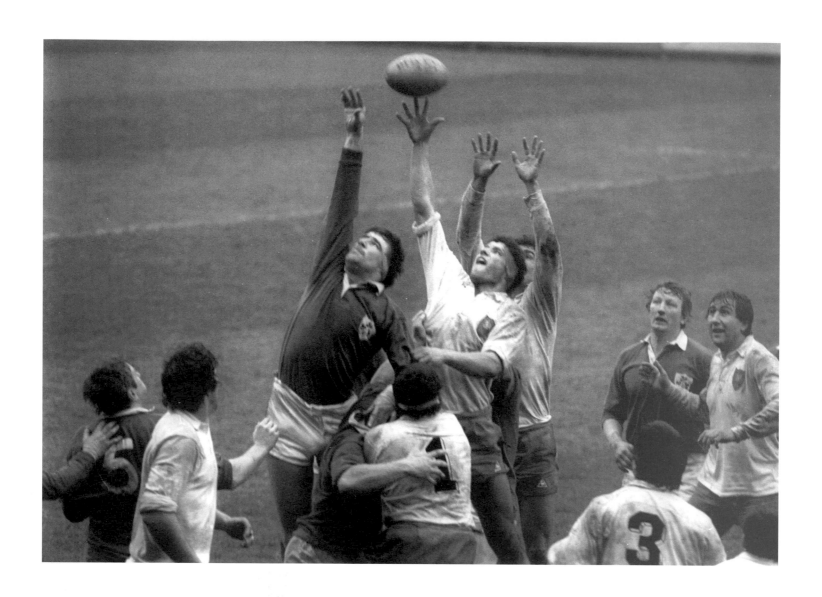

In 1984, France, unbeaten in seven matches, came to Lansdowne Road to face **Ciaran Fitzgerald's** Ireland. Here, **Donal Lenihan** jumps against **Jean Condom** and **Jean-François Imbernon.** Looking on are **Moss Keane** (5) and **Willie Duggan**, and France's **Pierre Dospital (**1), **Robert Paparemborde** (3) and **Jean-Luc Joinel** (right). **Moss Finn s**cored two tries and **Ollie Campbell** kicked four penalties for a 22–16 Irish win.

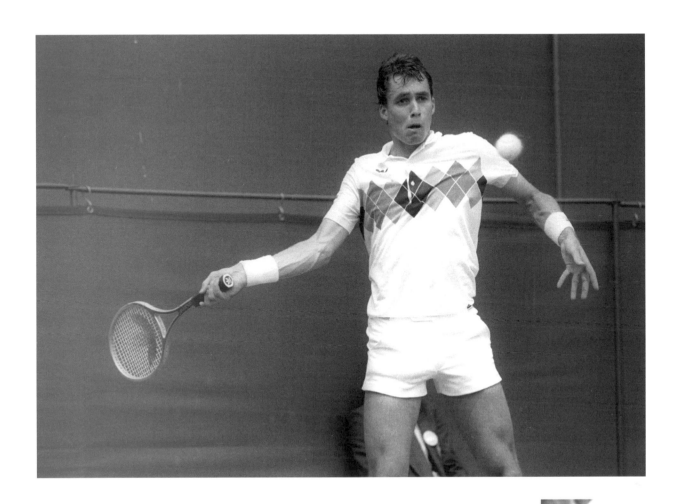

The Czech-born **Ivan Lendl** was not destined to win here at Wimbledon in 1983. But his long-time No. 1 ranking was justified by his Grand Slam record career tally of nineteen finals and eight wins, including three consecutive US titles.

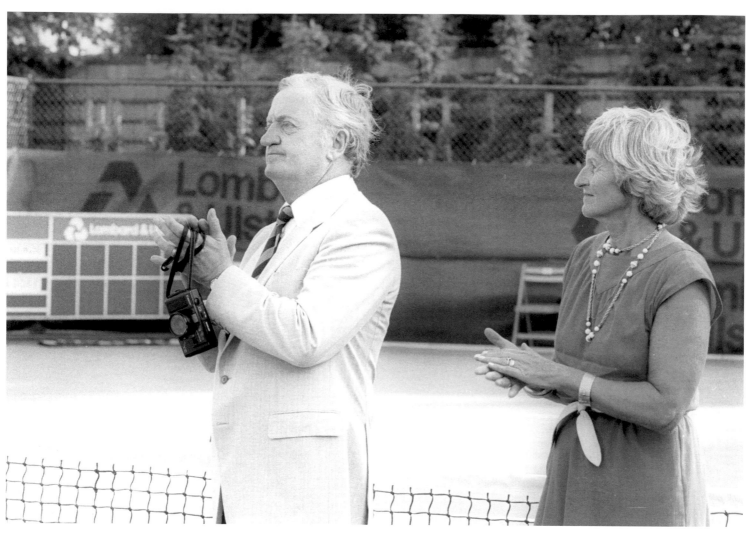

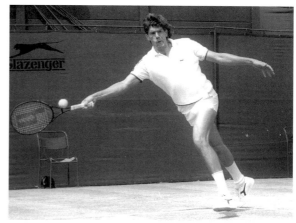

Mr Justice Niall McCarthy, the president of Fitzwilliam Lawn Tennis Club, with his wife, **Barbara**, at the prize ceremony for the 1984 Irish Open Championships. Tragically, in 1992 they both died in a road-traffic accident in Spain.

Matt Doyle at Wimbledon in 1983. The Californian-born Doyle is Ireland's most successful international player. Between 1981 and 1988, he won twenty-seven of his forty-four Davis Cup games for Ireland.

The Cork City Sports of 1985 brought together three Olympic hammer champions, who between them won five Olympic titles and set fourteen world records. They are, from left, **Harold Connolly** (USA), who won in Melbourne in 1956, **Yuriy Syedikh** (USSR), who won in Montreal in 1976 and in Moscow in 1980, and Ireland's **Pat O'Callaghan**, who won in Amsterdam in 1928 and in Los Angeles in 1932.

Mats Wilander (Sweden) plays in the 1985 GOAL Tennis Challenge in Dublin's Fitzwilliam Square. Wilander won thirty-three singles titles, including seven Grand Slam events.

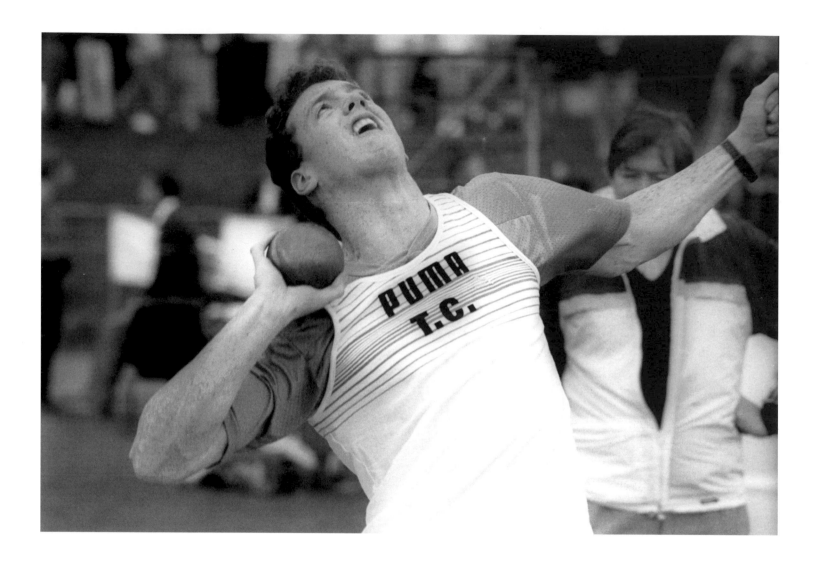

Victor Costello in 1988, the year he won the first of his four successive Irish shot-put titles. Abandoning athletics, he made his rugby debut for Ireland against the USA in 1996 and went on to win thirty-nine caps for his country.

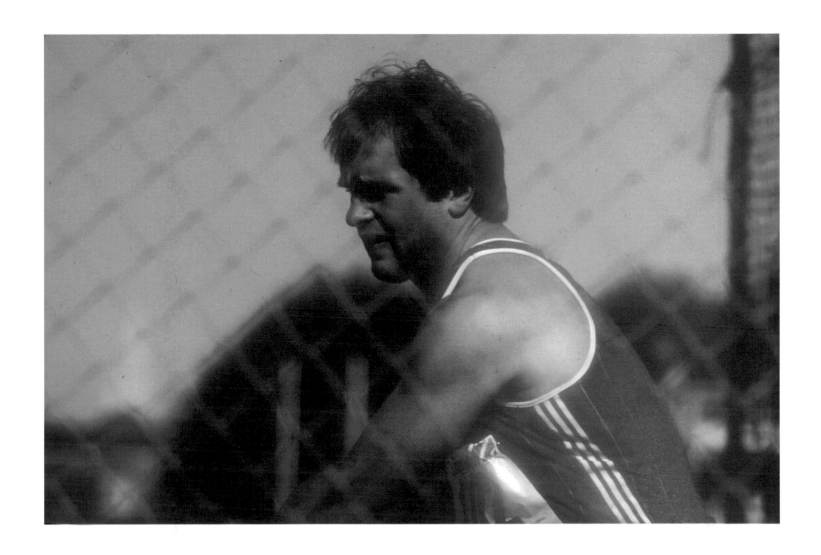

Yuriy Syedikh (USSR), the reigning Olympic champion, prepares himself in the circle before his world-record throw of 86.34 metres at the 1984 Cork City Sports. His compatriot and then reigning world record holder, Sergey Litvinov, lost out that day. In what was almost certainly the greatest event in the history of hammer-throwing, the two men beat the previous world record no fewer than six times. In 1986, Syedikh made two further improvements to the still-current record of 86.74 metres.

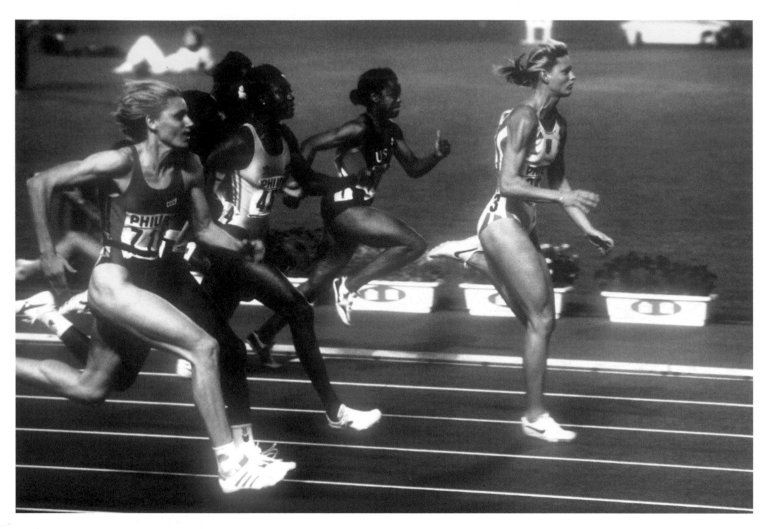

Katrin Krabbe (Germany) has a clear lead halfway to her 100 metres win at the Tokyo World Championships in 1991. In winning, Krabbe broke the fifty-six-race winning streak of **Merlene Ottey** (Jamaica), who finished third behind **Gwen Torrence** (USA). Within a couple of years, Krabbe was involved in two drugs scandals, the second of which resulted in a ban from the sport

Katrin Krabbe in Split during the 1990 European Championships.

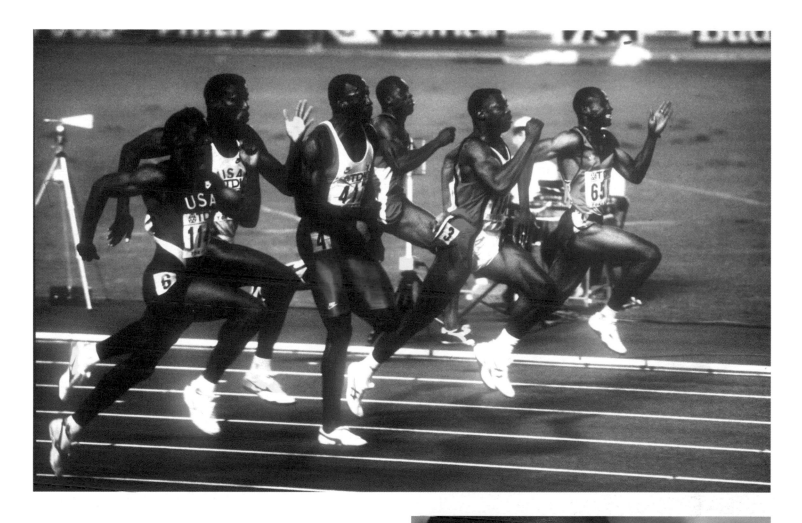

In this **1991 World Championships** 100 metres final, six men all broke ten seconds in personal-best times. The first four were **Carl Lewis** (US), **Leroy Burrell** (US), **Dennis Mitchell** (US) and **Linford Christie** (GB).

Carl Lewis talks to the press after taking the 100 metres gold in a world-record time of 9.86 seconds.

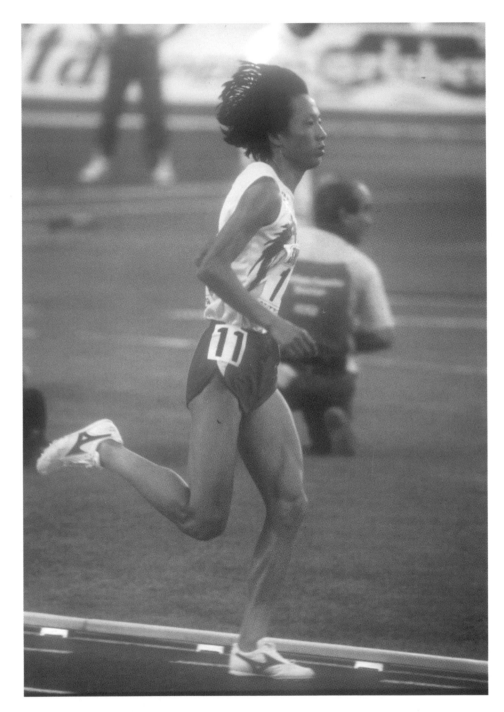

Junxia Wang (China) on her way to victory in the 10,000 metres at the 1993 World Championships in Stuttgart. A month later, she set the current world record at the distance, and five days after that she set the world record for the 3,000 metres. Wang was one of a group of Chinese women athletes who emerged from relative obscurity in the early 1990s.

Cavan's **Catherina McKiernan** winning the 1993 Irish National Cross-Country Championship in Dublin's Phoenix Park. It was the last of her five Irish cross-country titles, to go with her five track titles over 3,000 and 5,000 metres. McKiernan also won four consecutive silver medals in the World Cross-Country Championship (1992–5) and the first-ever European Cross-Country Championship (1994). Before her injury-enforced retirement in 2004, McKiernan won several major international marathon titles, including in Berlin (1997), London (1998) and Amsterdam (1998).

In Helsinki's Olympic Stadium, Ireland's **Terry McHugh** competes in the 1994 European Championships, in which he finished seventh with a throw of 80.46 metres. McHugh set the Irish javelin record of 82.75 metres at the 2000 Grand Prix in London's Crystal Palace. In 2004, he created a world record when he won the All-Ireland javelin title for the twenty-first time in a row. He represented his country in three Olympic javelin competitions. McHugh was also part of the Irish four-man bobsled team at the 1998 Winter Olympics in Nagano, Japan, where the team finished in thirtieth place, ahead of Greece and Puerto Rico.

Florence Griffith Joyner (1960–98) attended the 1991 World Championships as a spectator. At the 1988 US Olympic Trials in Indianapolis, she set a world record of 10.49 seconds for the 100 metres in circumstances that are disputed to this day. The wind which was recorded all day as blowing well in excess of the two-metres-per-second maximum for record purposes was recorded as zero during both of her heats. Adding to the controversy is the fact that twenty-eight-year-old Joyner's best previous time was 10.99 seconds. At the Seoul Olympics, she set two world records and won three golds, including one for the 100 metres, which she won by almost four metres. She also won a silver for the 4 x 100 metres before promptly announcing her retirement. Ten years later, Flo-Jo died of a heart seizure at the age of just thirty-eight.

Ireland's **Susan Smith Walsh** at the 1998 Cork City Sports. Smith Walsh won eight national titles over the 100 metres hurdles between 1989 and 2000. In the later part of that period, she moved up to the 400 metres hurdles, in which she won five Irish titles. In the longer event, she reached the Olympic semi-final in 1996 and was a finalist in the 1998 European Championships.

Maurice Greene (USA) in 1991, retaining his 100 metres World Championship title in Seville, where he also won over 200 metres. Greene added a third world title at Edmonton in 2001, having taken Olympic golds in the 100 metres and 4 x 100 metres at Sydney in 2000. Greene's dominance in the 100 metres is underlined by his having recorded fifty-two sub-ten-second times over the distance.

Cathy Freeman at the Seville World Championships in 1999, when she took one of her two 400 metres world titles. In 1992, Freeman was the first Aboriginal athlete to represent Australia at the Olympics. At the 1996 Games, she took silver before coming home in 2000 to light the Olympic flame and take the 400 metres gold in Sydney.

Cathy Freeman at Cork City Sports in 1998.

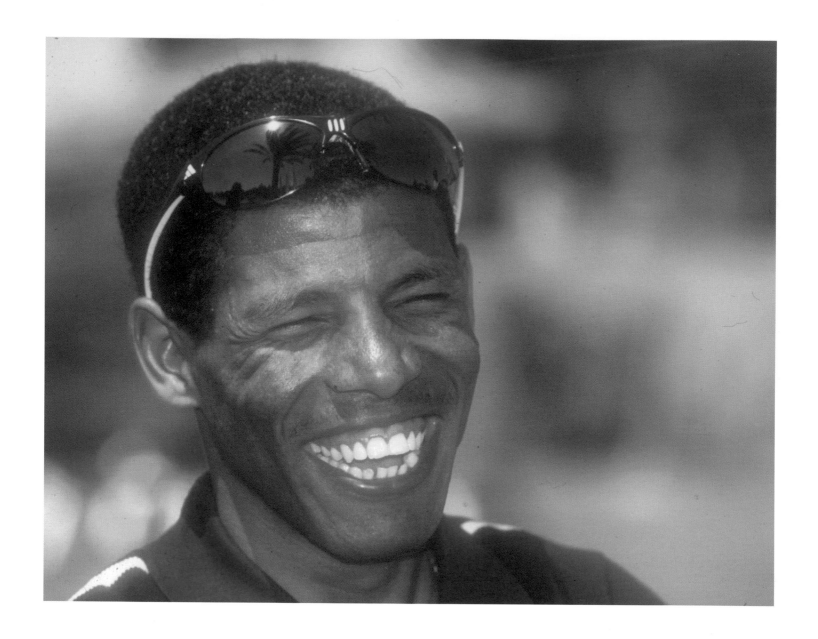

Ethiopia's **Haile Gebreselassie** in Seville before adding the 1999 World Championships title to his two Olympic golds, four world titles and three world records over 10,000 metres. In all, he set eighteen world records. More recently, he won medals in the 2001 and 2003 World Championships and was fifth in the 2004 Olympics.

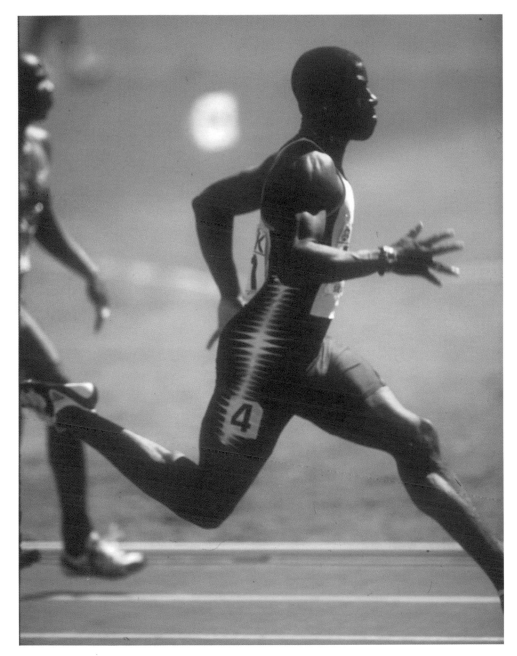

Dwain Chambers (GB) (below) at the 2003 World Championships in Paris, where he won a gold medal in the 4 x 100 metres relay.

In 2004, Chambers received a two-year ban for testing positive for the use of anabolic steroids. At the time of the ban, he was the reigning European 100 metres and 4 x 100 metres title holder.

Dwain Chambers at the 1991 World Championships in Seville, qualifying for the 100 metres final, in which he finished third.

IAAF president **Primo Nebiolo** (right) (1923–99) with Secretary of State for
Northern Ireland **Mo Mowlam** (1949–2005) at the 1999 World Cross-Country
Championships, which were held in Belfast in recognition of the importance of
the 1998 Good Friday Agreement.

Nebiolo at the 1994 World Championships in Helsinki.

Michael Johnson (USA) in Seville (above), where, as the reigning 200 and 400 metres Olympic title holder, he also took the 1999 World Championship titles for both distances.

Michael Johnson (right), after winning the 1991 World Championships 100 metres in Tokyo.

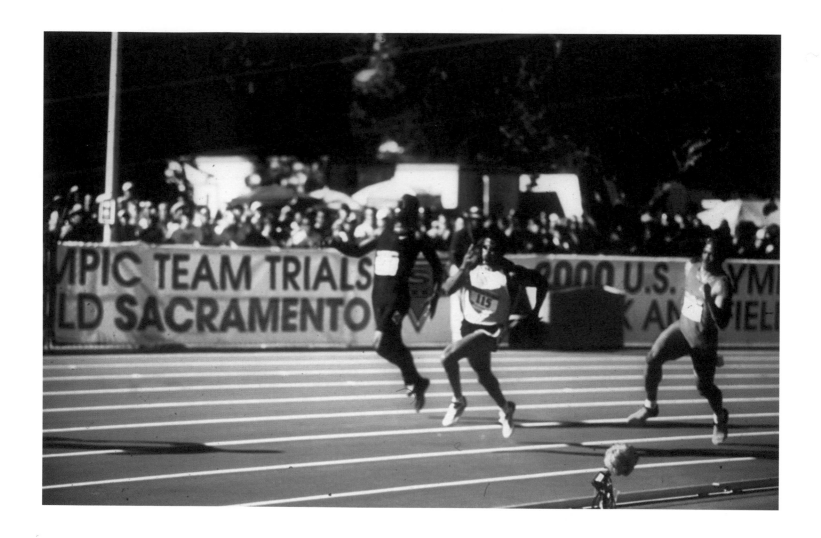

At the **2000 US Olympic Trials** in Sacramento, there was a long-awaited duel between the reigning world 100 metres champion, Maurice Greene, and the world and Olympic 200 metres and 400 metres champion, Michael Johnson. In previous days, Greene had won the 100 metres and Johnson the 400 metres, but now they were to meet over 200 metres. Johnson's agonised muscle pull after fifty metres was followed by Greene pulling up just forty metres further on. They both recovered to take golds in their respective events and the related relays at the Sydney Games, where a then little-known but subsequently notorious Greek sprinter, Konstantin Kenteris, took the 200 metres gold.

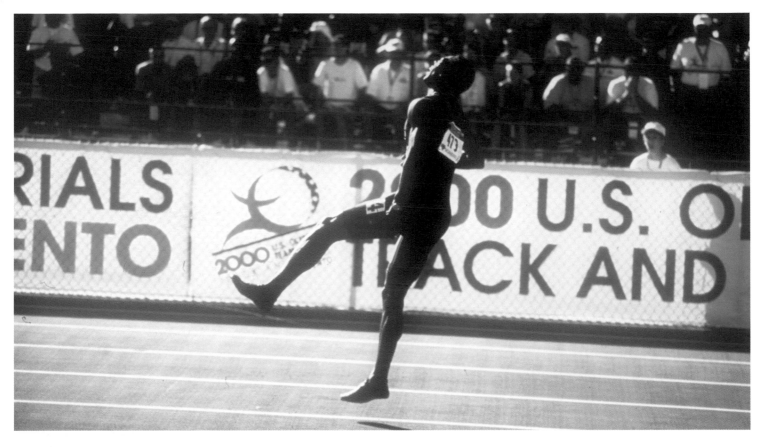

Jerome Young (USA) finished fourth in this 400m at the 1999 World Championships in Seville. A year earlier, he had been part of a still-recognised 4 x 400 metres world record-setting team. It subsequently became public that Young had failed a drug test a month before Seville but had been quietly exonerated by the USA Track and Field Federation without any further testing. That finding was eventually overturned by the USATF Doping Appeal Board in 2004 and Young received a lifetime ban.

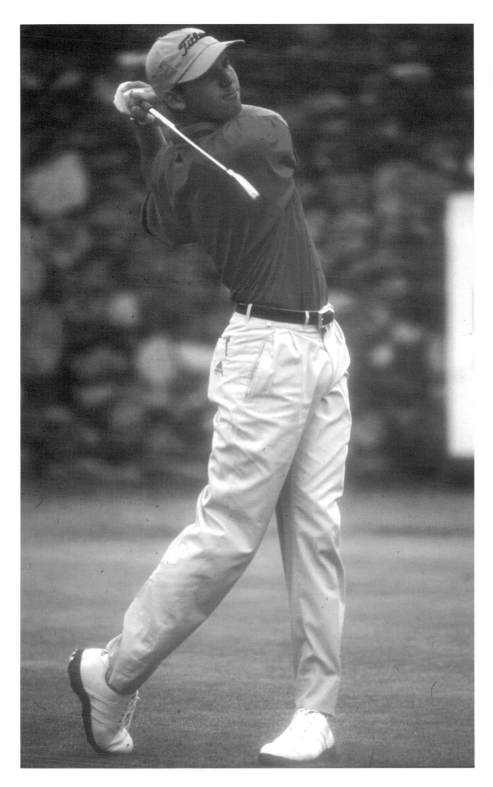

Sergio Garcia (Spain) on his way to his first professional win in only his sixth pro event, the 1999 Irish Open in Druids' Glen. Garcia also made the Ryder Cup team that year and figured prominently on the European Ryder Cup–winning teams in 2002 and 2004.

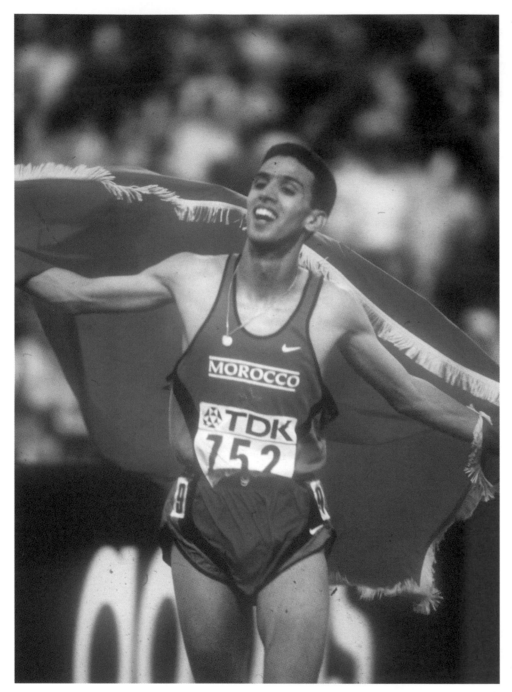

Hicham El Guerrouj (Morocco) in Athens in 1997 celebrating the first of his four World Championship 1,500 metre titles. Also pictured is his 1999 win in Seville (opposite, far right) and his 2003 win in Paris (opposite, right). In 2004, once again in Athens, El Guerrouj finally took 1500 metres Olympic gold, having tripped in 1996 and been narrowly out-sprinted at Sydney in 2000. Those two Olympic defeats were his only two defeats over 1,500 metres in the seven years to 2003. Four days later, he gilded the lily by becoming the first man in eighty years to do the Olympic 1,500 metres–5000 metres double. He holds the 1,500 metres, mile and 2,000 metres world records and is also the only man to have run the indoor mile faster than Eamonn Coghlan.

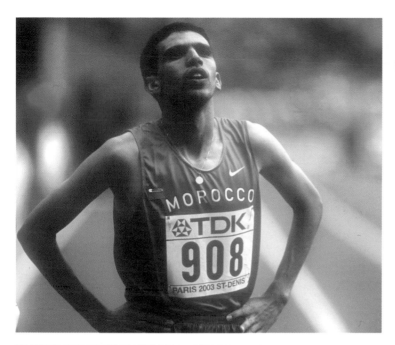

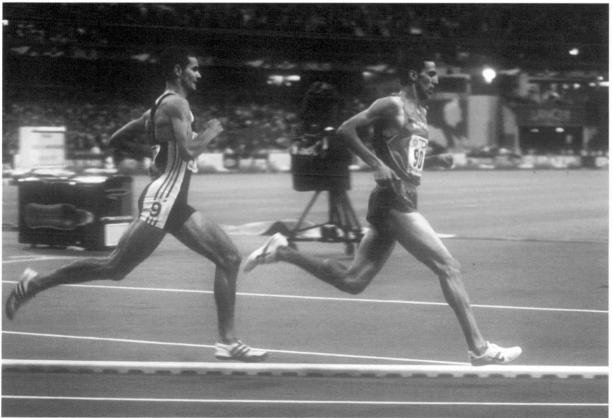

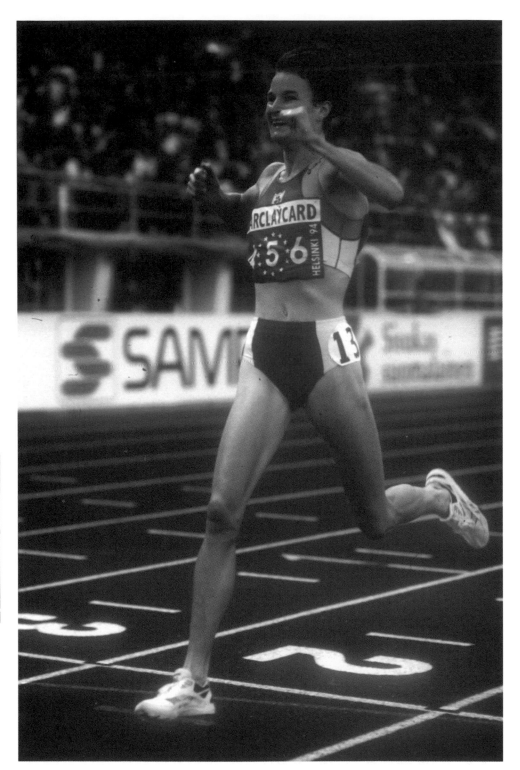

In 1994, **Sonia O'Sullivan** takes Ireland's first-ever gold medal in the European Championships, over 3,000 metres in Helsinki. She remains the reigning champion at that distance, which was abandoned in favour of the 5,000 metres after 1994.

O'Sullivan at the 1998 European Championships in Budapest, where she won both the 5,000 metres and 10,000 metres.

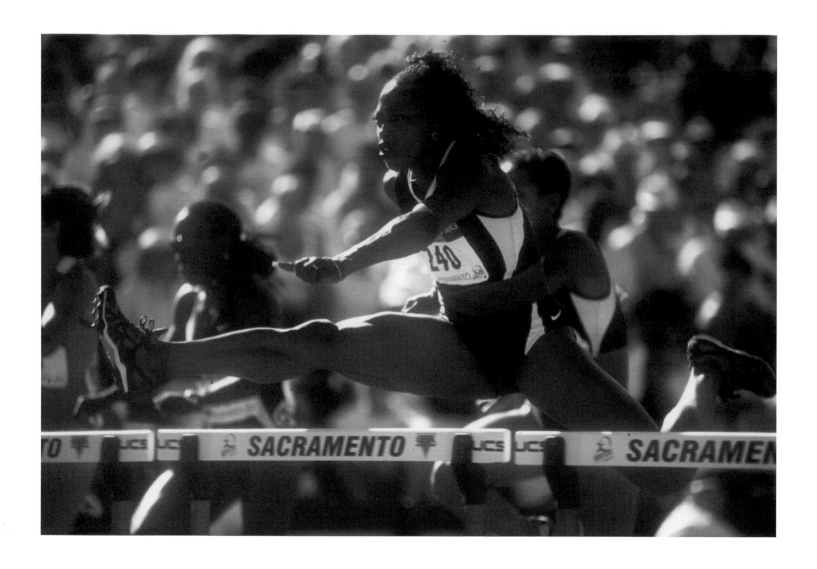

Gail Devers (USA) competes in the 100 metres hurdles at the 2000 US Final Olympic Trials in Sacramento. Devers made her Olympic debut in the 100 metres hurdles at the 1988 Seoul Olympics, when she finished last in her semi-final. A subsequent diagnosis of Graves Disease and the threatened amputation of a foot were overcome for her to come second at the 1991 Tokyo World Championships. Thereafter, Devers won three World titles, in 1993, 1995 and 1999. Comfortably in the lead at the 1992 Barcelona Olympics, she tripped on the last flight of hurdles and came in fifth. She was considerably consoled – and surprised – to take the 100 metres gold. This, she successfully defended in 1996, when she also won a 4 x 100 metres gold.

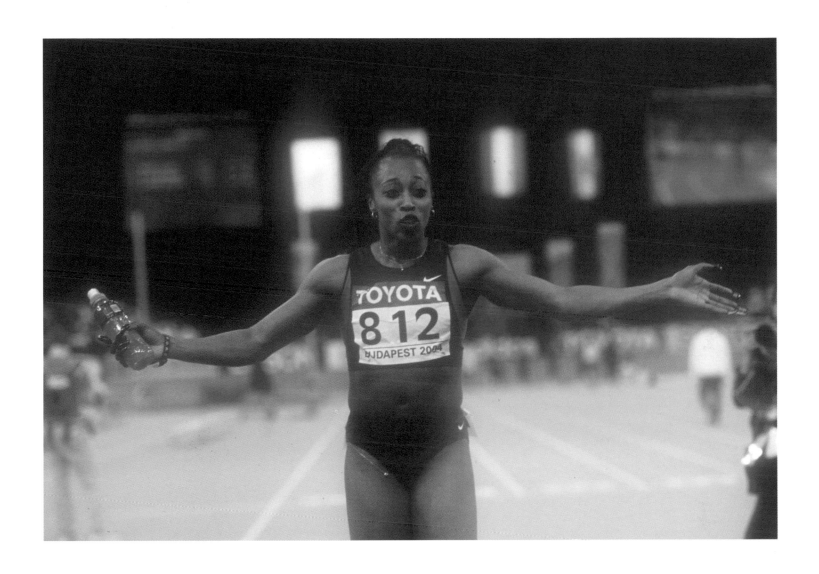

Gail Devers after winning the 60 metres title in Budapest in 2004.

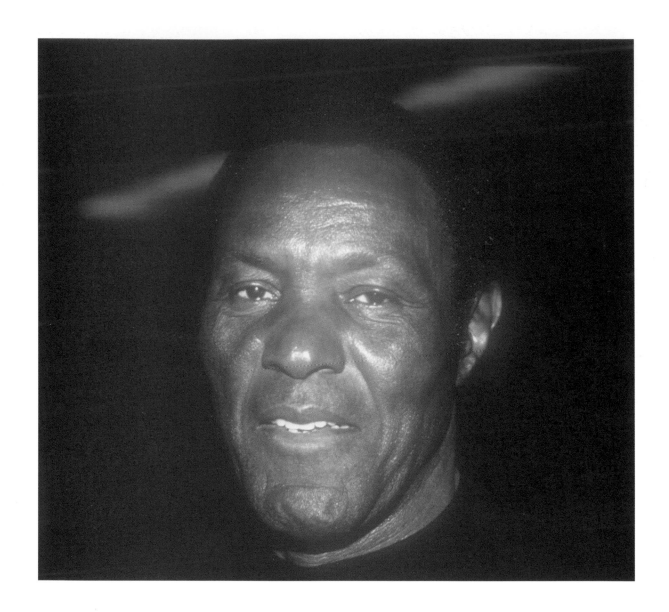

Rafer Johnson (USA) at the 2000 US Olympic Trials in Sacramento, forty years after his famous decathlon victory over Yang Chuan-kwang (Formosa) at the 1960 Rome Olympics.

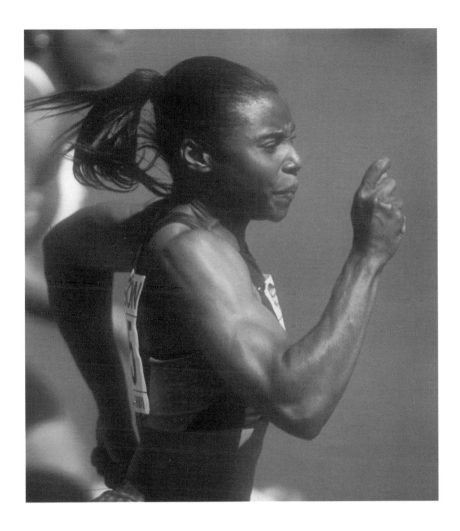

Kelli White (USA) competing at the 2001 World Championships in Edmonton, where the twenty-four-year-old Californian won a 4 x 100 metres gold and a bronze in the 200 metres. Two years later, at the World Championships in Paris, she won both the 100 and 200 metres titles. But within twenty-four hours, it was announced that she had failed a drug test. After initial pleas of innocence, she confessed. She subsequently became the whistleblower for the drugs investigation of the Balco Laboratory, which has led to bans for many athletes. White's own two-year ban, imposed at the end of 2004, bears the additional legend: 'All results by White from 15 December 2000 annulled.'

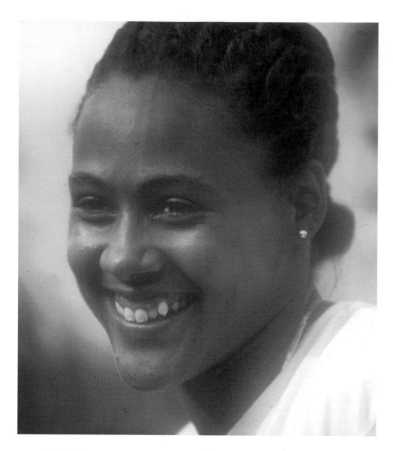

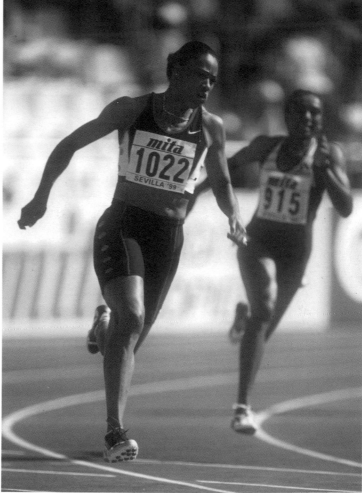

Marion Jones (USA) (top right) in action at the 1999 World Championships in Seville and (top left) at the 2000 US Olympic Trials in Sacramento.

Jones and her now ex-husband **C. J. Hunter** in Sacramento (bottom left).

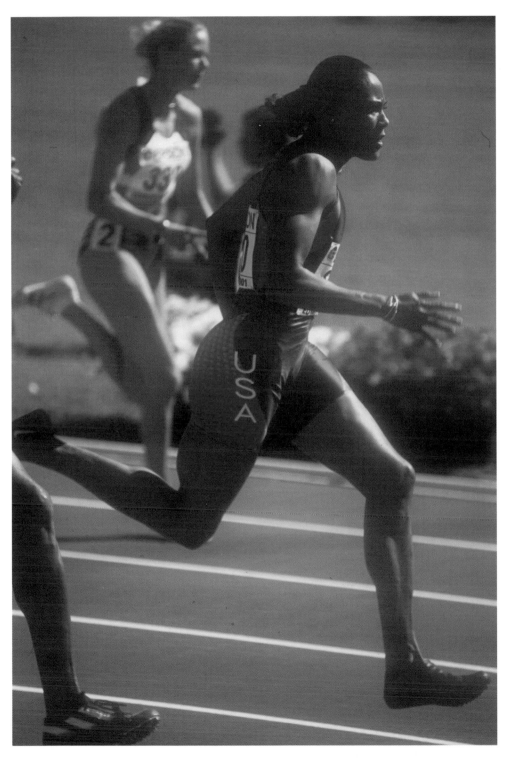

Marion Jones at the 2001 World Championships in Edmonton. As a sixteen-year-old, Jones abandoned athletics for collegiate basketball but returned to win 100 metres and 4 x 100 metres golds at the 1997 World Championships in Athens. The following year, she lost just one of her thirty-four individual events. She had sixteen of the fastest twenty times over 100 metres and was fastest over 200 metres that year, when she also married shot-putter C. J. Hunter. Both qualified for the 2000 US Olympic team before C.J. withdrew, citing an injury. It was soon confirmed, however, that he had failed four drug tests, including one which showed nandrolone at a thousand times the normal level. Jones won three gold (at 100 and 200 metres, and 4 x 400 metres) and two bronze (4 x 100 metres and long jump) medals in Sydney.

The 2001 World Championships brought her two more golds and a silver, and she was unbeaten in any individual event in 2002. Jones qualified only for the Olympic long jump in 2004, finishing fifth. That year also saw allegations, which Jones is still fighting, of her possible involvement with the discredited Balco Laboratory in California.

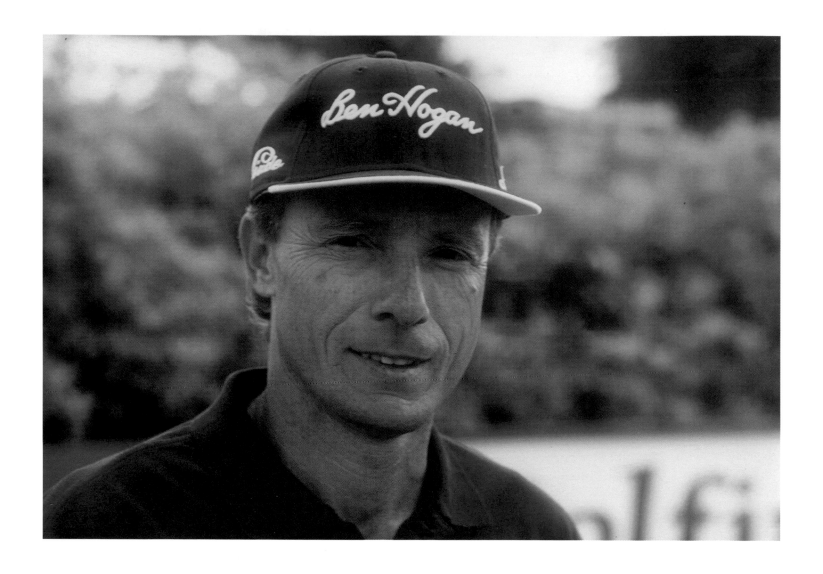

Bernhard Langer (Germany) pictured at the Smurfit European Open Championship in the K Club just after the announcement of his appointment as captain of the European team for the 2004 Ryder Cup. As captain, he was given much of the credit for Europe's win at Oakland Hills. Langer had previously played in ten Ryder Cup matches and won seventy tournaments, including two US Masters.

Kenenisa Bekele (Ethiopia) at the World Cross-Country Championships at Leopardstown Racecourse in 2002. Bekele had won the 2001 junior title when the event was transferred from Dublin to Ostend because of the foot-and-mouth scare. At Leopardstown, he prevaricated about running the short (4 kilometres) or the long (12 kilometres) course before turning out for the 4 kilometres race, which he won comfortably, on the Saturday. On the Sunday, he became the first man to complete the 4 kilometres–12 kilometres cross-country double. (Sonia O'Sullivan had done the women's equivalent at Marrakech in 1998.) Bekele repeated this remarkable feat in 2003, 2004 and 2005. He won the 2003 World 10,000 metres track title in Paris (below) shortly before breaking his compatriot Haile Gebrselassie's 5,000 metres and 10,000 metres world records. Bekele achieved all of this before his twenty-second birthday, shorly after which he took the 10,000 metres Olympic gold in Athens.

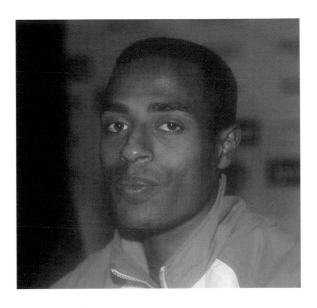

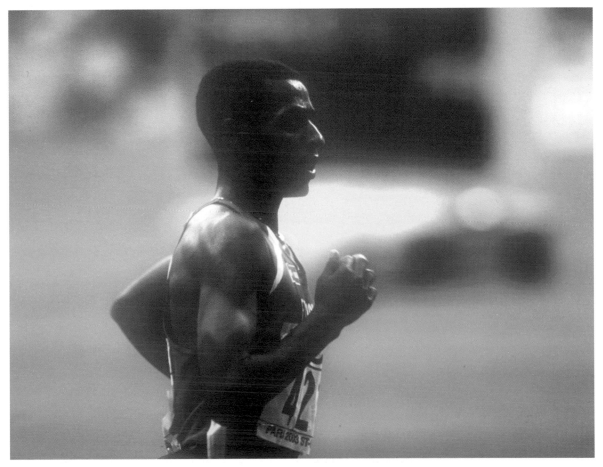

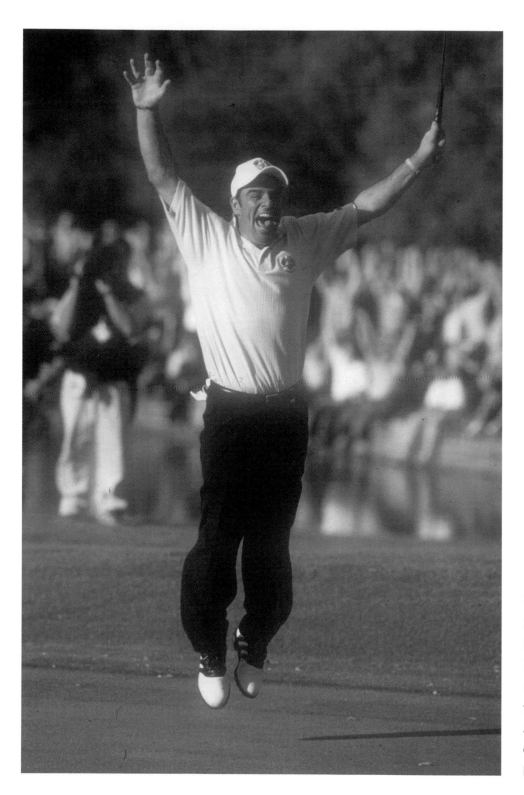

Paul McGinley realises that his ten-foot putt on the eighteenth green at the Belfry has clinched victory for the European Ryder Cup team in 2002. He subsequently played a major role in helping Europe retain the trophy in 2004 and hopes to win a place on the team for the 2006 Ryder Cup – to be played at the K Club, where he was once the playing professional.

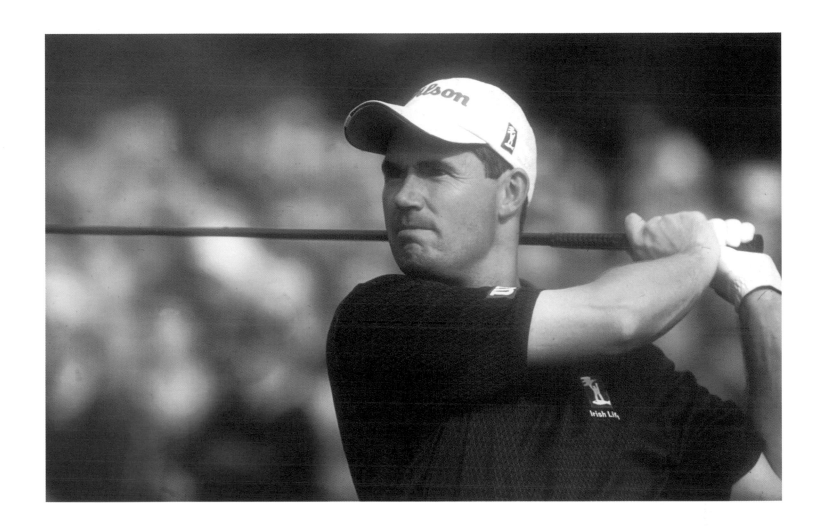

Padraig Harrington playing in the 2002 World Golf Championship at Mount Juliet, County Kilkenny. In March 2005, Harrington beat Vijay Singh (Fiji) in a play-off at the Honda Classic Tournament in Florida to win his first US PGA Tour title. The Irishman took a second US Tour title in the Barclays Classic in June. He has played on three European Ryder Cup teams and, in partnership with Paul McGinley, won the 1997 World Cup for Ireland.

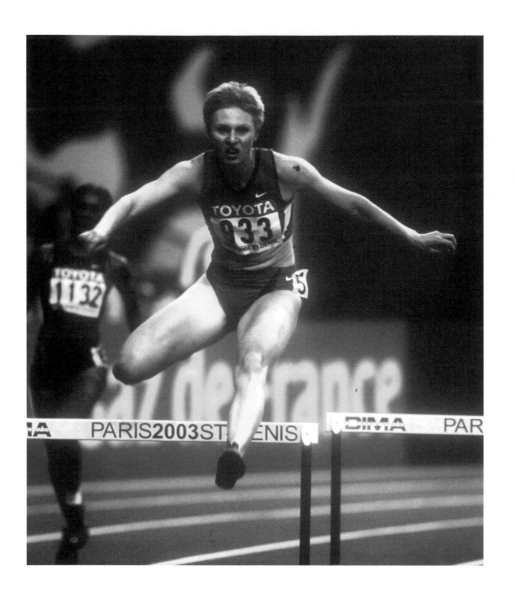

Yuliya Pechonkins (Russia) had broken the 400 metres hurdles world record shortly before her arrival in Paris for the 2003 World Championships, where this photograph was taken. Leading here over the seventh flight, she was overhauled before the finish by Jana Pittman (AUS) and Sandra Glover (USA). Pechonkins subsequently returned to take gold in Helsinki at the 2005 World Championships.

Hestrie Cloete (South Africa) in Paris, where she won her second World Championship high jump title in 2003. Her winning height of 2.06 metres remains her lifetime best and means that she is ranked joint fourth in the all-time rankings. She took Olympic silver in both 2000 and 2004.

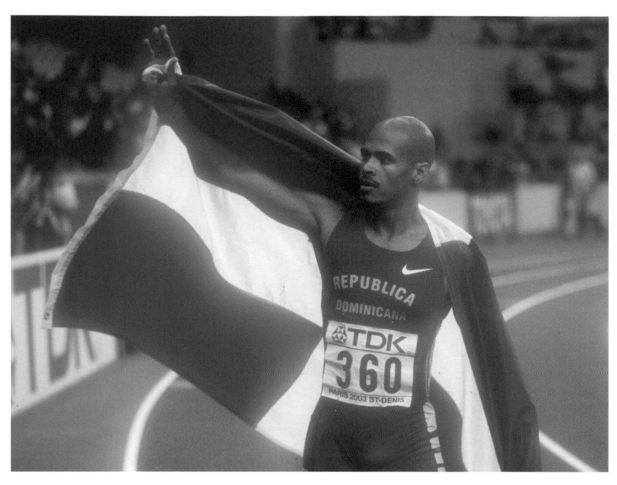

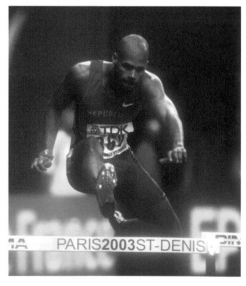

New York–born **Felix Sanchez** (Dominican Republic) at the 2003 World Championships in Paris, where he took his second 400 metres hurdles world title. In 2002, Sanchez was one of four athletes to share in the Golden League prize of 50 kilogrammes of gold. He took Olympic gold in Athens and was unbeaten in forty-three 400 metres hurdles races between July 2001 and September 2004.

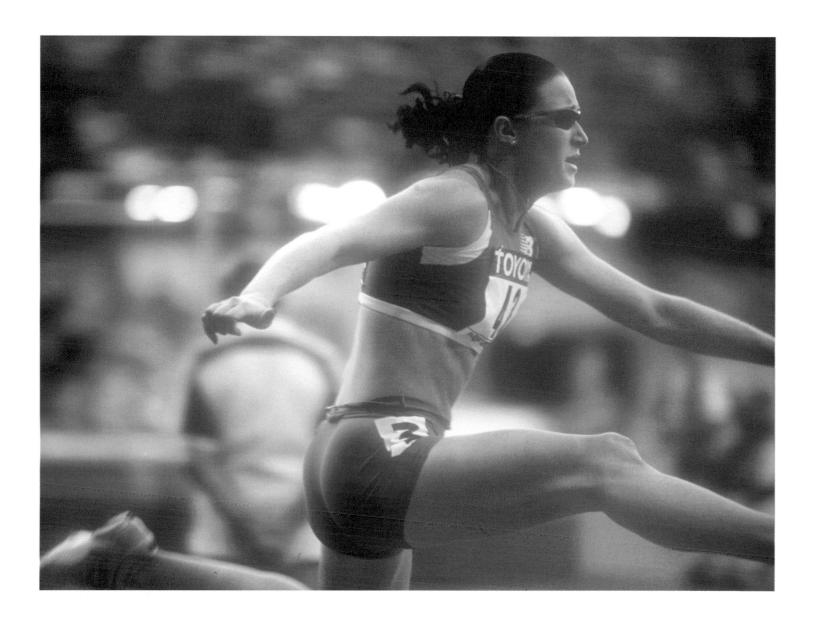

Jana Pittman (AUS) on her way to winning the 400 metres hurdles at the 2003 World Championships in Paris. Uniquely, she had won both the 400 metres and the 400 metres hurdles at the 2000 World Junior Championships. Sadly, an injury before the 2004 Athens Olympics meant that she achieved a relatively modest fifth place at these Games.

Darren Clarke from Dungannon, (above) at the Pro-Am before the 2004 Nissan Irish Open at Baltray. Clarke turned professional in 1990 and has since amassed European Tour winnings alone of more than €10 million.

Darren Clarke (above right) during the 2003 Nissan Irish Open at Portmarnock.

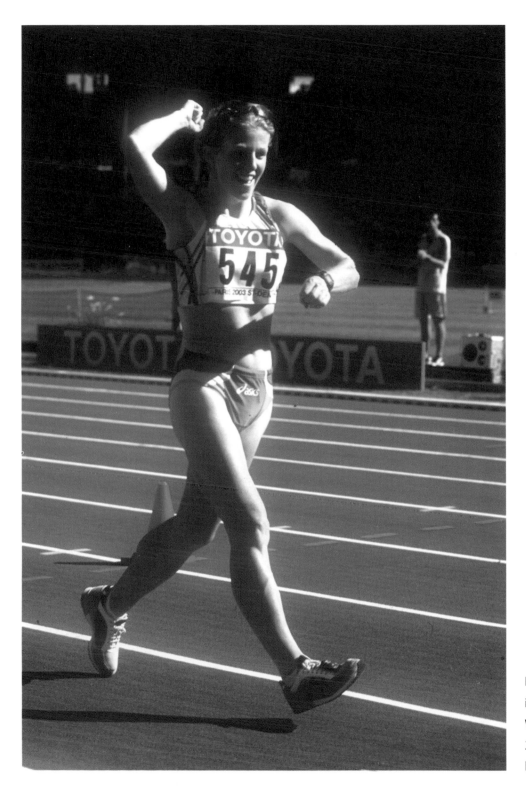

Ireland's **Gillian O'Sullivan** taking silver in the 20 kilometres walk at the 2003 World Championships in Paris. Her 2004 and 2005 seasons were severely hampered by injury.

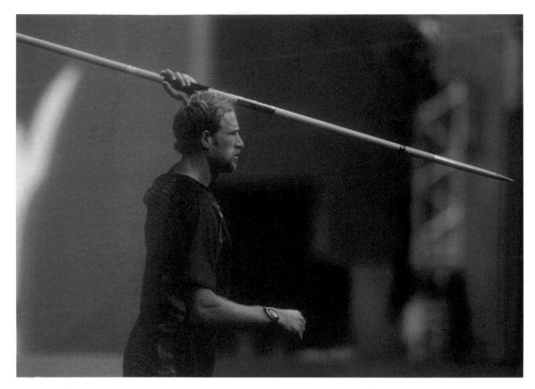

Tom Pappas (USA) on his way to defeating world-record holder Roman Sebrle (Czech Republic) to win the 2003 World Championship decathlon title in Paris. Pappas had already won the World Indoor heptathlon title in 2003. A favourite for the 2004 Olympic title, he injured himself during the pole vault and was forced to withdraw.

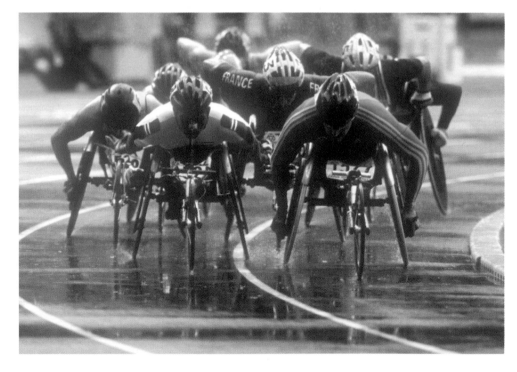

The 1,500 metres at the 2003 World Athletics Championships in Paris saw **Ernst Van Dyk** (South Africa) lead from **Prawat Wahorum** (Thailand) on the second lap before both faded, letting **Jean Jeannot** (FR) come through in the centre to take the title.

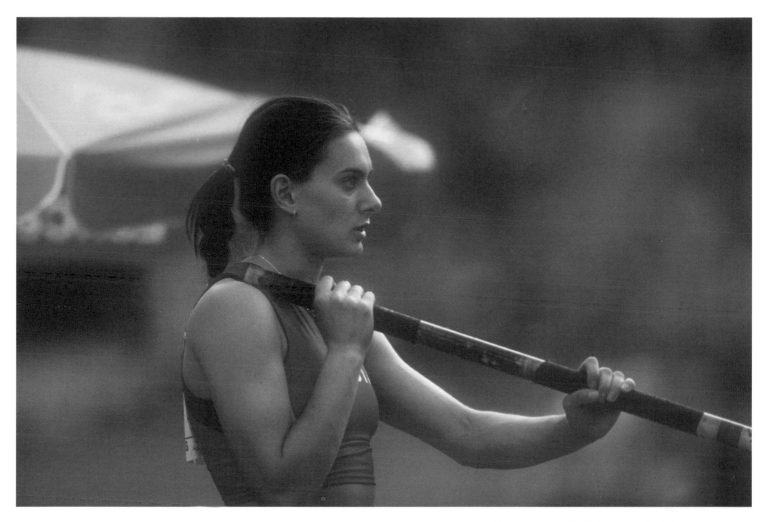

Yelena Isinbayeva (Russia) at the 2003 World Championships (above) in Paris, where, unusually, she took only bronze, behind her great Russian rival Svetlana Feofanova. Since her first world record, of 4.82 metres at Gateshead in 2003, Isinbeyeva has won Olympic gold – and no fewer than eleven world records, each carrying a bonus of $50,000 – as she inches her way towards the 5-metre mark.

At the 2004 World Indoor Championships in Budapest, **Isinbayeva** raised a few eyebrows with an attempt at 5 metres which failed, possibly deliberately. She finally made a 5-metres clearance at London's Crystal Palace in July 2005 before taking the World Championship title in Helsinki.

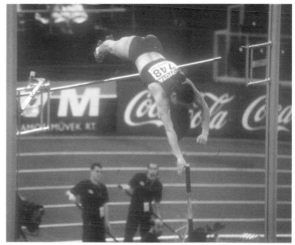

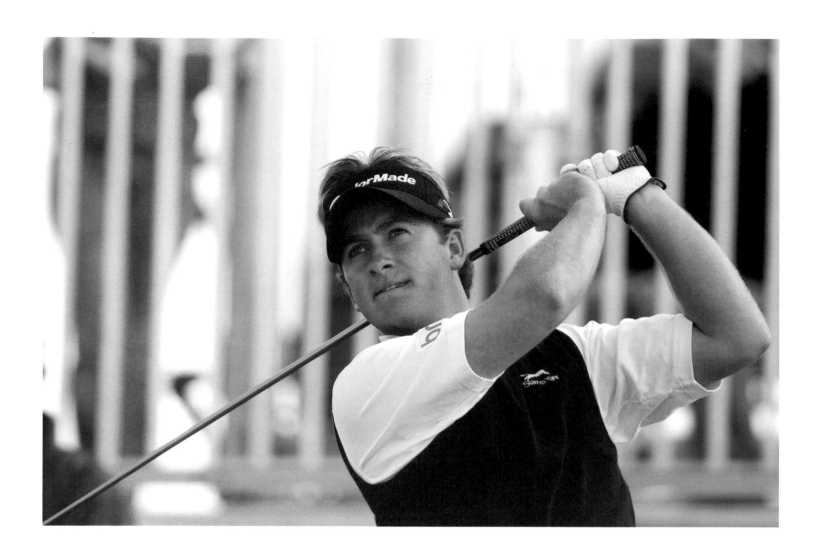

Graeme McDowell playing the 2004 Nissan Irish Open in Portmarnock. This former Ulster boys and Irish youth champion from Portrush attended Alabama University, where he broke collegiate records previously held by Tiger Woods and Luke Donald. McDowell made his professional debut at the 2002 Murphy's Irish Open on Fota Island and a month later claimed his first European Tour title, the Scandinavian Masters in Sweden.

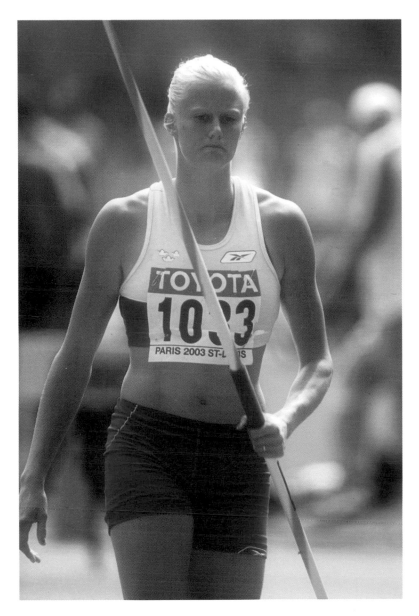

Carolina Klüft (Sweden) preparing for the javelin and warming up for the shot-put events in the heptathlon at the 2003 World Championships in Paris. This 2000 world junior heptathlon champion went on to retain that title in 2002, when she also won the European equivalent – setting two world records in the process. In 2003, she secured the world senior title before taking Olympic gold in 2004 and the World Championships title in 2005.

Michael Campbell (NZ) at the 2005 Smurfit European Open Championship at the K Club. Although he finished down the field on that occasion, he won the event in 2002 and the Irish Open in Portmarnock in 2003. Before coming to the K Club, Campbell won the 2005 US Open and later beat Paul McGinley in the final of the 2005 World Matchplay.

Perdita Felicien (Canada) celebrating at the 2004 World Indoor Championships in Budapest after adding the 60 metres hurdles title to her 2003 Paris world 100 metres hurdles title. Later in 2004, Felicien was favourite for the Athens Olympic title but hit the first hurdle in the final and fell, taking out a Russian rival in the process.

Tiger Woods grimacing through the pain of an injury to play the second hole in the 2004 Amex World Championship Tournament at Mount Juliet. He completed that and three further rounds to finish ninth, behind winner Ernie Els.

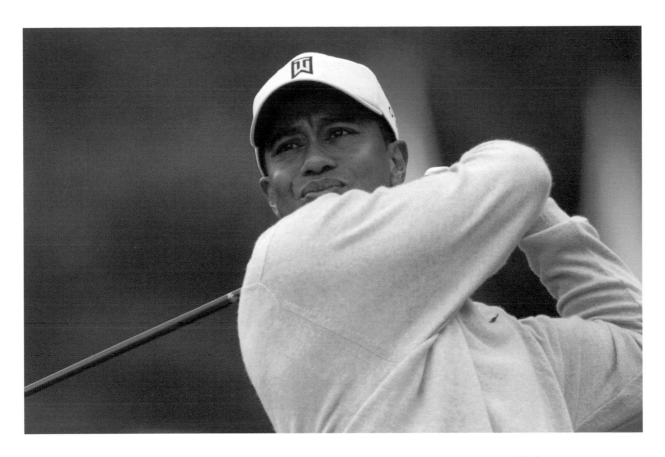

Tiger Woods drives off at the 2005 J. P. McManus Invitational Pro-Am at Adare Manor and (below) in a precarious position on the tenth green during the 2002 Ryder Cup at the Belfry.

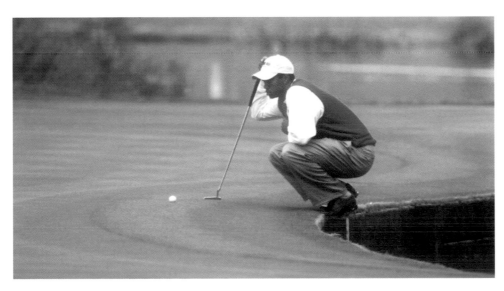

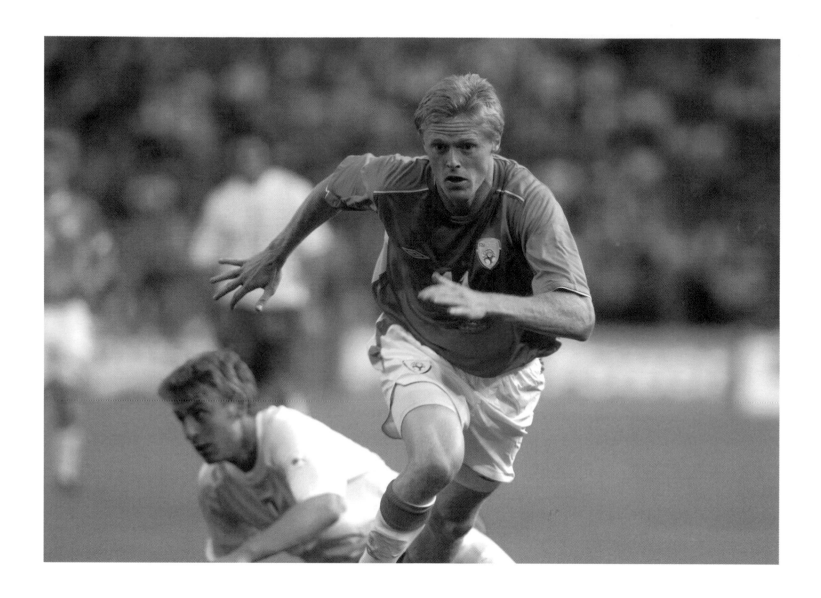

Damien Duff gets away from his man during the 2005 World Cup qualifier against Israel in Lansdowne Road. Ireland lost a two-goal lead to draw 2–2, seriously jeopardising their chances of qualification for Germany in 2006.

Roy Keane watches Ireland's 2005 World Cup qualifier against Israel from the touchline in Lansdowne Road.

The event which really gave the necessary momentum to my efforts to get this book published came from the generous decision of the current partners in my former firm, McCann FitzGerald, Solicitors, to support the venture. I only hope that, with the benefit of hindsight, they will not now think that, in my eighteen years as a partner, my mind was more often on sporting rather than legal issues! It is particularly pleasing to me that they are incorporating some of my photographs in the décor of their new offices when, next year, they move south of the Liffey to Sir John Rogerson's Quay. My sincere thanks go to Ronan Molony, Managing Partner, and his colleagues.

I must thank my friend Jimmy Magee, who has kindly agreed to contribute the Foreword to this book. In the same vein, I must express in advance my gratitude to a great friend and great athlete, John Treacy, who has agreed to launch the book which, deservedly, features a number of pictures of John in those days when he was winning World Championships and an Olympic silver medal.

Essentially, my wife Margaret – we celebrate a Golden Wedding Anniversary in January – and all my six children joined in the chorus that I should do a book like this, and they have all, and particularly Margaret, remained steadfastly encouraging and, at times, tolerant of my

concentration on the project. I thank them all for this, but special thanks are due to two of the children: Jean's marketing experience has played a constant and vital role as the work progressed, but without Richard I would have gone nowhere. His IT and PR expertise was absolutely crucial in bringing photographs and text in a presentable state to the publishers; it really was a case of 'no Richard – no book'.

Obviously, I have not seen the finished product but I have seen sketches and proofs at various stages along the route and I really believe that my photographs are being presented in the best possible manner. For this, I must thank the entire production team – designer Joanne Murphy (a fine photographer in her own right) and Seán O'Keeffe and Peter O'Connell, the Directors of Liberties Press. Thanks also to Peter Pigot of WPPS for his invaluable assistance and input at the proposal stage of this project. I hope that the sales are sufficiently large to make meaningful my decision to give my royalties to the Irish Hospice Foundation, a very worthy cause.

Fionnbar Callanan
Dublin, November 2005